LEGENDARY

OF

EASTPOINTE

MICHIGAN

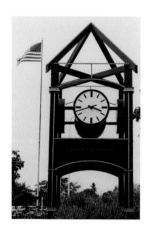

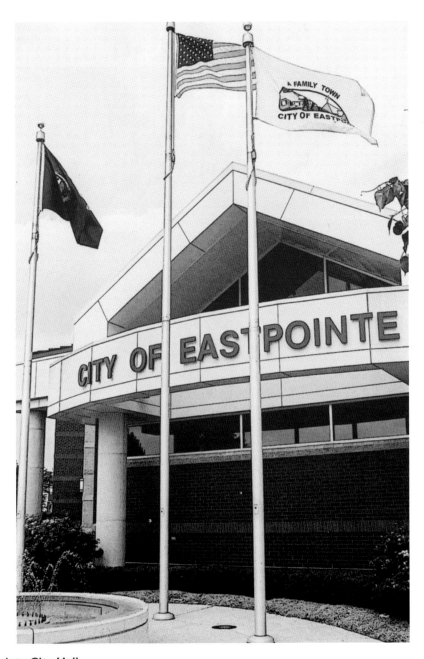

Eastpointe City Hall
Opened in October 2008, the new city hall provides for easy use by residents, access to administration, and a bright space for open meetings of the city council, board of education, and other commissions. It is partially surrounded by a plaza containing a stage for concerts and a veteran's memorial (see page 102). (Photograph by Marco Catalfio.)

Page 1: City of Eastpointe Clock Tower
The clock tower was built in the center of the Downtown District Authority to salute First State Bank, which had erected its first building at the same corner 90 years before. (Photograph by Marco Catalfio.)

LEGENDARY LOCALS
—— OF ——

EASTPOINTE

MICHIGAN

Suzanne DeClaire Pixley

SUZANNE DECLAIRE PIXLEY

LEGENDARY
LOCALS

Legendary Locals is an imprint of Arcadia Publishing
Charleston, South Carolina

Printed in the United States of America

Library of Congress Control Number: 2012941767

For all general information, please contact Arcadia Publishing:
Telephone 843-853-2070
Fax 843-853-0044
E-mail sales@arcadiapublishing.com
For customer service and orders:
Toll-Free 1-888-313-2665

Visit us on the Internet at www.arcadiapublishing.com

Dedication
To the historians, photographers, and record-keepers who dedicated themselves to preserving Eastpointe's history.

On the Cover: From left to right:
(TOP ROW) Bill Taylor Jr., florist (Courtesy of Bill Taylor, page 65); Karen Semrau Regan, businesswoman (Courtesy of Karen Regan, page 60); Christian Nill, businessman and mayor (Courtesy of City of Eastpointe, page 62); Mildred Stark, mayor (Courtesy of City of Eastpointe, page 81); Dan Zander, crossing guard (Courtesy of Dan Zander, page 52).
(MIDDLE ROW) Robert Kern, mayor (Courtesy of City of Eastpointe, page 76); Robert Brown, photographer (Courtesy of Robert Brown, page 45); Harvey Curley and Cardinal Adam Maida, mayor and cardinal (Courtesy of Harvey Curley, page 88); Carl Gerds II, fire chief (Courtesy of Carl Gerds III, page 84); Francis Andary, Korean War veteran (Courtesy of Francis Andary, page 98).
(BOTTOM ROW) Leo LaLonde, Army journalist (Courtesy of Leo LaLonde, page 26); Sue Young, picture lady (Courtesy of Sue Young, page 44); Bob Kern, mailman (Courtesy of East Detroit Historical Society, page 76), Mario Cercone, businessman (Courtesy of Mario Cercone, page 66), Jerry Linenger, astronaut (Courtesy of East Detroit Historical Society, page 100).

CONTENTS

ACKNOWLEDGMENTS

The author gratefully acknowledges the work of all prior East Detroit/Eastpointe historians whose records, data, and photographs serve as the backbone for this book. For sharing their personal photographs, I thank Sue Young, Judge Carl Gerds, retired police chiefs Ron Gerds and Mike Lauretti, Gregg Knobloch, Al Marco, the Palleschi family, Marie Guerra, Michelle Taylor, former US congressman Dave Bonior, former Michigan state representative Leo LaLonde, Francis Andary, Ken Giorlando, Bill Schwedler, Kathy Keenan, Carol Middledorf, Claire Kansier, Joyce Vincent, Veronica Belf, Nick Sage, and Harvey Curley. A special thanks to the City of Eastpointe for the use of former mayors' photographs from the city archives.

Many new photographs were also taken, and credit needs to be given to the photographic technical advice and skills of John (Mike) Zyckowski, photography instructor for continuing education at Macomb Community College; Melody Walters, a certified fine art photographer; and Marco Catalfio, for his patience, understanding, and talents. Special thanks also go to the photograph department of Sam's Club, store No. 6662, especially Norma and Jenny, who assisted in so many ways.

I also wish to acknowledge Gerry Kaminski and Larry Andrewes from the East Detroit High School Athletic Hall of Fame committee, who helped provide photographs and athletic records researched and preserved by that group. Librarians Sue Todd, Carol Sterling, and the Eastpointe Public Library staff were also of assistance.

A thank-you also goes out to Arcadia editors Tiffany Frary and Erin Vosgien for their advice, patience, and support. Finally, I'd like to thank my family, friends, and colleagues for their undying support, patience, and understanding as the book made its way to completion.

INTRODUCTION

The area in southeast Michigan now known as Eastpointe seems to have gone through an identity crisis during its history. Originally, it was part of Orange Township, so named because of the Scotch Irish of Northern Ireland. While some moved to the area, many had bought large pieces of property during initial government land sales as the Northwest Territory was settled by the white man. Most of these buyers had done so as a financial opportunity. Shortly thereafter, with an influx of immigrants from the southern part of Ireland, the name was changed to represent their homeland—Erin Township. As famines and revolutions occurred across Europe, successive immigrations brought some English, but, for the most part, the highest percentage of people moving in were from Germany, France, and the European Low Countries. While it was still known as Erin Township, the area came to be known as Halfway because of its location—halfway between the City of Detroit and the county seat of Mount Clemens.

There were early settlers of the area who became legends in their own way. In the case of James Moss, it was because of the advanced farm equipment he used. Nicholas Ameis and his son were legends as they altered their business with the changing times, shifting from general store to horse market to hardware store, carrying everything from organs to vacuum cleaners. The Spindler and Rein families became lasting legends because of the parks that now bear their names.

As the area developed, a group of progressive businessmen sought to establish community services, including fire and police protection, street improvements, and water and sewer lines. Knowing it would require collective action to accomplish these goals, they established the Village of Halfway. Leaders of this first group included Henry Hauss, the Reins, George DeClaire, and others equally involved. With the success of the village form of government, it seemed necessary to move ahead with establishment of a city government. An administrator was brought in to manage affairs, under the control of a mayor and city council. A charter was developed, and the area was again renamed, this time the City of East Detroit.

Leaders of this era were of a political bent. The first mayor, Robert Kern, was a member of a family that had lived in the area for almost 100 years when he was elected. Some of the other leaders at the time were the Reins, the Rausches, Henry Hauss, Christian Nill, Charles Beaubien, and Chris Kaiser. They possessed brilliant visions of the future, and were able to adapt when the Great Depression changed the entire financial picture of the area.

During the 1940s, the atmosphere of the city began to change. Many women had succeeded at work in the local armories while men were away during World War II. Though some continued to work when the men returned, most became stay-at-home moms. However, they began collectively to apply the work skills that had made them independent thinkers in Mothers Clubs. These clubs had as their goals to accomplish what they thought was important for their families, such as decreasing the distances required to go to school, obtaining school buses for transportation, and acquiring new furnaces for the school buildings. If the school board would not buy a piece of equipment for them, they raised the funds, bought the equipment, and had it installed. Occasionally, the demands became very verbal as they filled school board and city council chambers, protesting things they did not feel were good for their families. One of the most outspoken members of the Mothers Clubs was Betty Hayes, who became the first woman to be elected to East Detroit's city council. She was easily elected because of the high proportion of women voting. A year later, a female mayor, Mildred Stark, was appointed and later elected. In the case of these two women, legendary lives were forged that will probably never be repeated. Changes to the city were so rapid that many men gave up and resigned their positions.

East Detroit's population expanded rapidly in the 1950s, as did the number of churches and schools. Athletes broke high school records left and right and accomplished a great deal at state and college

levels and at the professional level. Names like Moss, Lisabeth, Kramer, Ballman, and Walker have been enshrined beyond local halls of fame. Music and art filled the air during the late 1950s and 1960s, with residents receiving accolades on various levels. The works of Mary Giovann, to name just one artist, continue to dazzle viewers.

Hopefully, the last identity crisis occurred in the 1990s, when George Lawroski proved that, with a great deal of determination, one person could change the direction of an entire city. Leading an outspoken group, he was able to successfully petition for three different elections that eventually led to the city's name being changed from East Detroit to Eastpointe.

In the ensuing pages, you will read about just some of the past and present Eastpointe residents who have become legendary.

CHAPTER ONE

History

Those who cannot remember the past are condemned to repeat it.

—George Santayana

Figures from Eastpointe's history date to the mid-1800s, when waves of migration came to the area from Canada, Germany, England, and Scotland. Most migrants were seeking religious freedom, a safe location for their families, and educational opportunities for their children. These people were for the most part farmers who worked hard and had success with their crops. Those who chose to start small family businesses succeeded with new ideas as the population increased and the area slowly developed. They came together to help each other, to work as a community, and to provide service to those around them. Their inspiring stories speak of the ups and downs of that period. Today, we celebrate the past as we study these residents' lives, reenact their skills, and preserve what they have contributed to modern society.

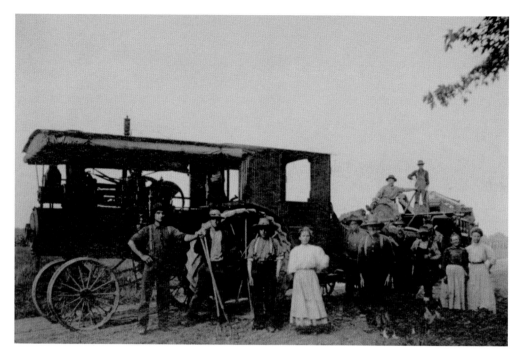

James Moss

James Moss was one of the most popular men in the area when he bought this steam-powered threshing machine. Most of Erin Township's farmland was covered with wheat, hops, and some barley, as well as the usual farm products. Judging by the size of the machine, it is easy to see why historical records indicate that one could hear young Jim from a mile away. (Courtesy of the East Detroit Historical Society.)

1917 Map of Southern Erin Township

This map shows the 32.5 acres of the James Moss farm. The farmhouse, indicated by the dot, is located at the southern edge along Base Line Road (now frequently called Eight Mile Road). Moss's father had purchased this property for $4 an acre when the family came to Michigan in 1852. As was common at the time, his in-laws, the A. Niedermiller family, owned the adjoining lot, 4.5 acres just to the west of Moss's northern property lines. (Courtesy of the Eastpointe Memorial Library.)

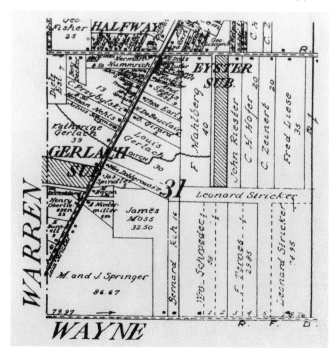

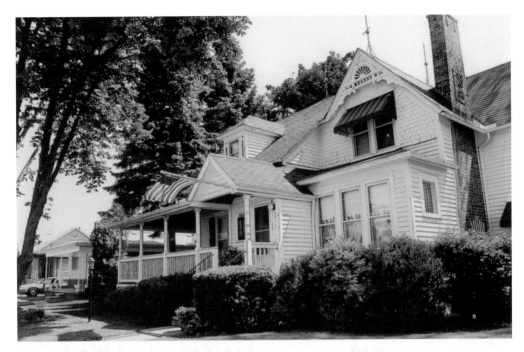

Moss Farmhouse
The Moss Farmhouse has changed a great deal in appearance since it was built in the mid-1800s by James Moss and his father. The original section of the house is pictured with the single dormer and awning. A fireplace was added about 1895, then a porch extension, which was later enclosed, followed by another living area on the north side. In the 1940s, when East Detroit was subdivided, the whole house was picked up and turned so that it now faces Universal Avenue, not Base Line Road. In the 1990s, a wraparound front porch was added. The home is currently occupied by the sixth-generation descendant of James Moss. (Courtesy of the East Detroit Historical Society.)

Ed Young
A sixth-generation descendant of James Moss, Ed Young (right) was as active as the earlier Moss family in community affairs. With five boys among his six children, it was natural that Young would become involved with community sports, particularly baseball and hockey. He was also involved with St. Veronica Church, volunteered as an officer in neighborhood groups, served on multiple commissions, and acted as mayor pro tem with the Eastpointe City Council before his untimely death. Young is seen here with Wes McAllister. (Courtesy of Darlene Sue Young.)

Erin Township's 1917 Map
This map shows the northwest section of what would become, in 1924, the village of Halfway. Fairly large farms still dot the map, and the population was limited to just a few thousand for the entire township. (Courtesy of Eastpointe Memorial Library.)

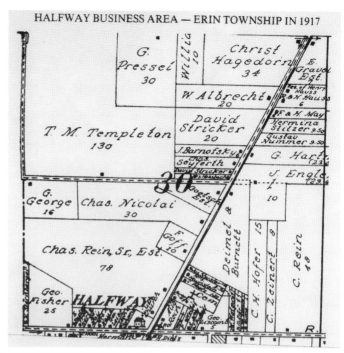

HALFWAY BUSINESS AREA — ERIN TOWNSHIP IN 1917

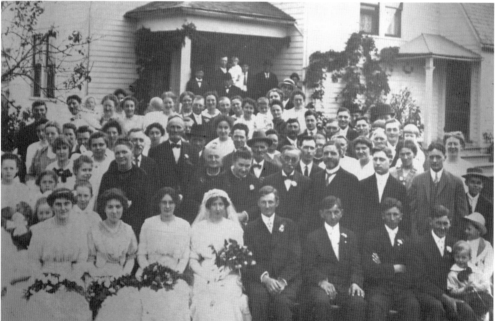

The Hagedorn Wedding
This appears to be a much-anticipated event in the early 1900s. From the above map, one can see that the Hagedorn farm totaled 34 acres and stood at the corner of Kern Road (now Ten Mile Road) and Gratiot Avenue. The farmhouse shown here was at the corner of the property. Judging by the number of people attending this event, and Halfway's sparse population at the time, it would appear that Chris Hagedorn was one of the most popular farmers of the area. (Courtesy of the East Detroit Historical Society.)

Paul Spindler

Paul Spindler was a descendant of another family that settled in what is now Eastpointe in the early 1840s. The Spindlers were successful farmers, later branching into business. The last of their farms in the Eastpointe area was a 46-acre lot on what is now Stephens Road. The 1917 map shows the farmhouse facing Stephens at the corner of what is now known as Kelly Road. (Courtesy of the East Detroit Historical Society.)

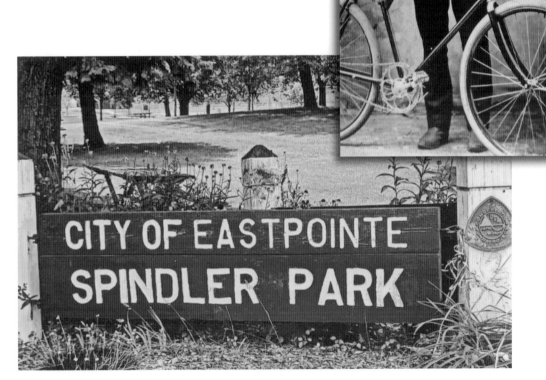

Spindler Park

Spindler Park was originally acquired from the Spindler family as a playground in 1956, when the city purchased former farm property between Stephens Drive and Spindler Avenue. The Stephens frontage was deeded to the East Detroit School District for construction of the Kellwood Elementary School, with an agreement for mutual use of the property for recreational purposes. In October 1969, the city acquired an additional 16.4 acres of land extending to the I-94 expressway between Stephens Drive and Nine Mile Road. Since that time, a park building, lighted tennis and shuffleboard courts, a baseball diamond, a picnic shelter, and other facilities have been added. In 1978, a Nature Project grant from the Michigan Department of Natural Resources was received to develop a tree-identification trail of 25 species native to southern Michigan. A separate trail also identifies 13 species of shrubs common to the area. (Photograph by Marco Catalfio.)

Charles Rein

Charles Rein and his wife, Wilhelmina, were pioneers who settled in Erin Township in 1844. This memorial rock was placed in what is now Rein Park (located just west of Gratiot Avenue, between North and South Park Streets) at the exact location of their original farmhouse. According to the 1917 map, the farm, which was then owned by son Charles, was still 78 acres in size. When the area was subdivided, the family donated part of the original farm to the Village of Halfway as a memorial park to the pioneer Reins, with the condition that the memorial rock remain in its exact location. (Photograph by Marco Catalfio.)

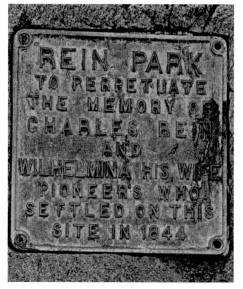

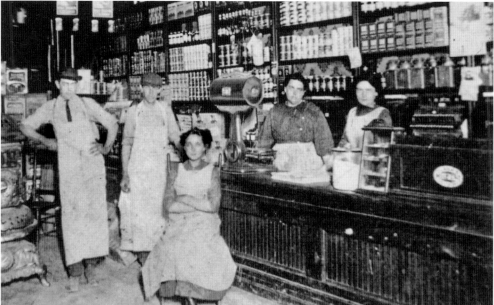

August Rein

August Rein, from the original Rein family, wanted to do more than run a farm. He attended St. Peter's Lutheran School, high school in Detroit, and graduated from the Detroit Business College. He returned to Erin Township to manage the very successful Rein General Store (shown here) and later became the postmaster, a position he maintained for 15 years. He wanted the area to develop and worked feverishly for a charter commission for the Village of Halfway, followed by another for the village to become the City of East Detroit. He felt strongly that education was important for the children of the city, and served on the board of education for 27 years as secretary and treasurer. A believer in service organizations' ability to benefit the community, Rein became the president of the East Detroit Kiwanis Club after working with others to establish the organization. He was married in 1889 to Anna Gerlach, the daughter of another pioneer family. (Courtesy of the East Detroit Historical Society.)

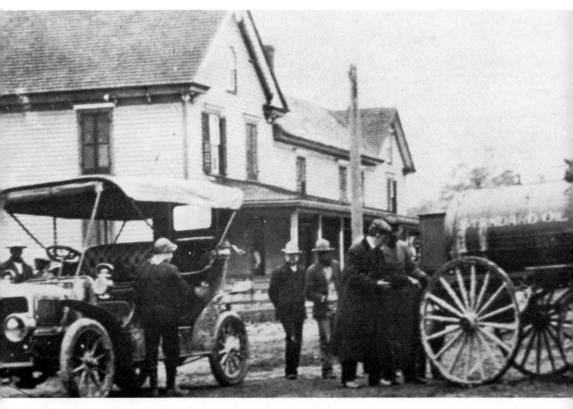

George Hund

In the late 1800s, George Hund bought the building seen here. It served as a general store, tavern, and brewery for over 60 years. George was a smart businessman who recognized the potential of his location on Gratiot Avenue at Eight Mile Road. It was the perfect place for the earliest drivers to test their skills and the endurance of their automobiles. He slightly exaggerated things in his advertising, suggesting that Gratiot was a "turnpike." In reality, the road was rough, uneven, and often covered with mud. Still, the new drivers made their way on Gratiot, finding that their cars could usually just about make it eight miles out of downtown Detroit before they needed refueling—and a rest stop at Hund's tavern. What is today a 25-minute trip took the early drivers six to eight hours. Pictured here is one of the first Standard Oil Company gas delivery systems, which Hund conveniently arranged to park at Hund's. It delivered gas directly from the large tanks on the horse-pulled wagon. Hund's soon became known as one of the first gas stations on the Gratiot Turnpike. (Courtesy of the East Detroit Historical Society.)

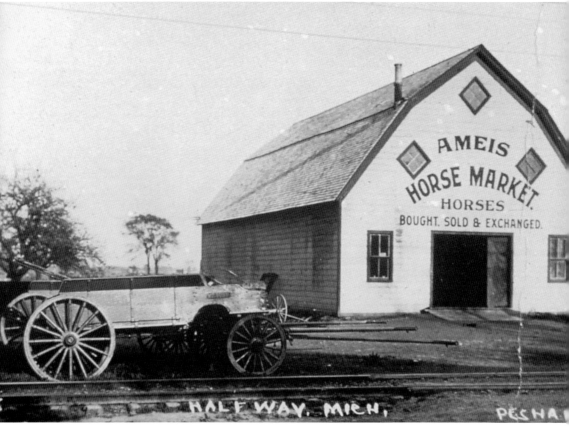

HALF WAY, MICH,

PESHA

Nicholas Ameis Sr. and Jr.

Father and son, Nicholas Ameis Sr. and Jr. were probably two of the most successful area businessmen of the late 1800s. Nicholas Ameis Sr. built a general store on the northeast corner of Gratiot Avenue and Nine Mile Road, and it became very successful. As Nicholas Ameis Jr. grew older, he joined his father in the business, expanding it with different types of merchandise. At the time, he saw a need for quality equipment for horses, wagons, and buggies, and soon set up his own business, the Ameis Horse Market, on the west side of Gratiot, just south of Nine Mile Road. He not only sold the equipment needed for horses and buggies, but also bought and exchanged horses. With the development of the automobile, Nicholas Jr. sold his horse market and built a large hardware store across the street, offering an expanded variety of merchandise, including vacuum cleaners, organs, and sewing machines. (Courtesy of the East Detroit Historical Society.)

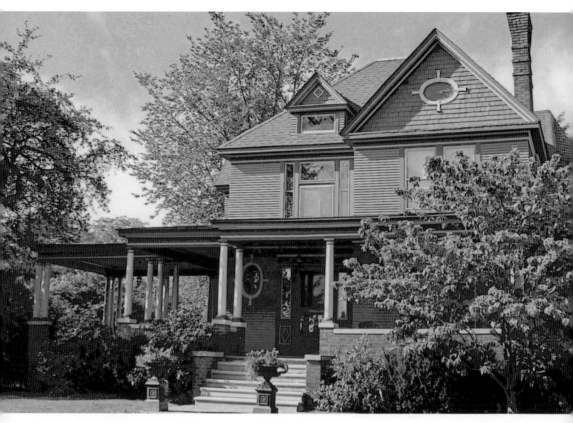

The Ameis Residence

When it was built in the early 1900s, the Ameis residence was the largest home in the Halfway area. Originally located in what is now the East Brooke Commons area, it was sold and moved to its current location on Nehls Avenue, west of Gratiot Avenue, in the early 1920s. Over the years, it changed ownership many times, and even became an apartment building at one point. In the 1990s, the Eastpointe City Council scheduled the decaying building for demolition. Mela and Ken Leiter bought the home and have worked diligently to return it to its original luster. (Photograph by Marco Catalfio.)

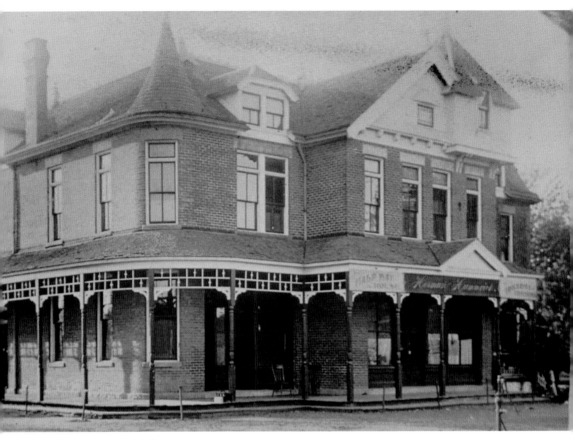

Herman Hummerich

Another ambitious entrepreneur who recognized that a general store on every corner would not be successful, Herman Hummerich bought the old Jacob Gaukler General Store in 1883. It was located on a prime spot: the southwest corner of Nine Mile Road and Gratiot Avenue. Hummerich demolished it and built the Halfway House. For close to 50 years, the building served not only as a tavern, hotel, and meeting place, but also as the location of the town's first bank and first post office. The building was razed in the early 1940s to make way for a shopping center anchored by Cunningham's Drug Store, Neisners Five and Ten, and Wrigley's Super Market. (Courtesy of the East Detroit Historical Society.)

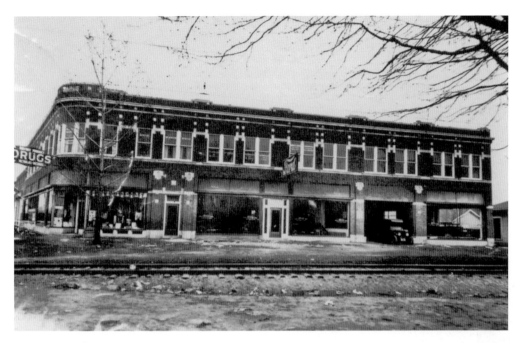

Chris Kaiser

Beginning as a successful truck farmer, Chris Kaiser recognized that with new development, people would no longer burn wood to keep their homes warm. He also realized that, as the area developed, real estate would be lucrative. Profits from his real estate activities allowed Kaiser to start his own coal business in 1904, complete with a small office and delivery trucks. In 1920, he purchased the property on the southeast corner of Nine Mile Road and Gratiot Avenue, which he felt would be the key location for economic development in the growing area. He built the two-story Kaiser Building, giving him the opportunity to provide space for retail shops, apartments, a dance floor, and other office space. In 1923, he opened Kaiser Motors—one of the first Ford dealerships in southeast Michigan. When the Village of Halfway was formed in 1924, the village offices and library were located in the basement of the building. (Courtesy of the East Detroit Historical Society.)

Chris Kaiser

Kaiser Fuel & Supply was moved in 1921 from the Kaiser Building to the location at Virginia Avenue and Nine Mile Road. At the time, the Erin Township Schools were auctioning off the Halfway Schoolhouse. Chris Kaiser recognized the architectural value of the Italianate design and decided to purchase and preserve the building, using it as a storeroom in the interim. The building was bought at auction and placed on skids, then moved over half a mile of icy roads by horses with winches. Kaiser covered the original floor and wainscoting, as well as all of the windows and other Italianate features, thus preserving the building. It was later sold to the schools and moved back to its original location. (Courtesy of Harold Kaiser.)

19

Glen Krueger

Eastpointe resident Glen Krueger recognizes that, while historical preservation is essential, it is equally important to learn about the basic skills that were part of everyday life for the area's pioneers. Glen is a member of the French Voyageur group, which studies the early French fur traders who explored and lived along the Great Lakes. As such, he has researched and studied the practices of blacksmiths and flint makers. He is pictured here at a recent encampment, in which the Voyageurs set up camp and conduct public demonstrations of the skills that were used in the 17th and 18th centuries. (Courtesy of Glen Krueger.)

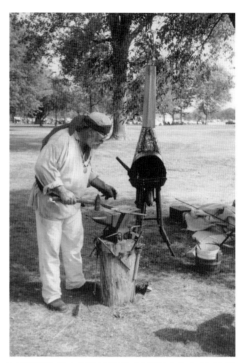

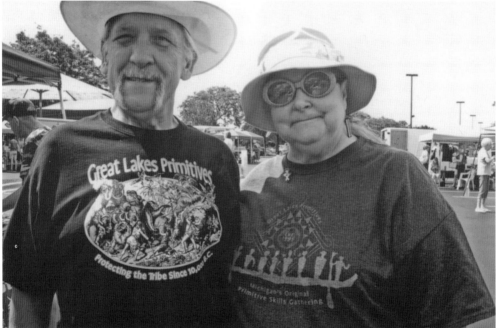

Dave and Hazel Michalski

Dave and Hazel Michalski are part of another group of historians who preserve what are called "primitive skills." These are the techniques and traditions of the native tribes of the Great Lakes area. During meetings and long weekends, learned skills and activities are developed among members and then shared with the general public at various gatherings. (Photograph by the author.)

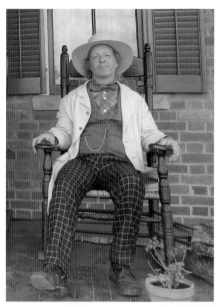

Ken Giorlando
Giorlando is another Eastpointe resident who works diligently to preserve history. While his focus is on preserving Civil War history through reenactments, he is also involved in researching, performing, and preserving music from the 17th, 18th, and 19th centuries. He is pictured here playing the role of a postmaster from the 1860s. Ken also volunteers a great deal of time, talking about the Civil War and life in the 19th century to schoolchildren as well as to multiple adult groups. (Courtesy of Ken Giorlando.)

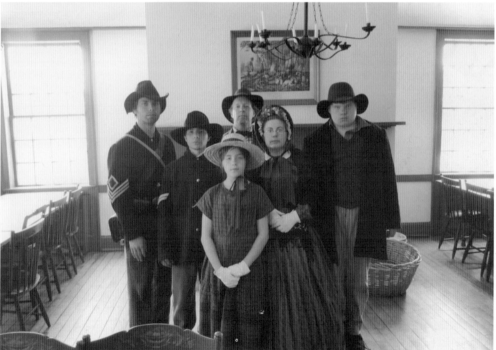

The Giorlando Family
The Giorlando family eventually followed Ken when they discovered the fun of historical reenacting. His wife, Patti, took sewing and hat-making classes, hand-sewing all the clothes for herself and her daughter, Rosalea. Son Tommy (far left) has now advanced through the ranks of the 21st Michigan Infantry re-enactment group, while son Robbie (second from left) plays a fife. Miles (far right) plays the role of a private citizen. The family travels throughout Michigan with the 21st Michigan Infantry, staging campouts and participating in battlefield reenactments. (Courtesy of Ken Giorlando.)

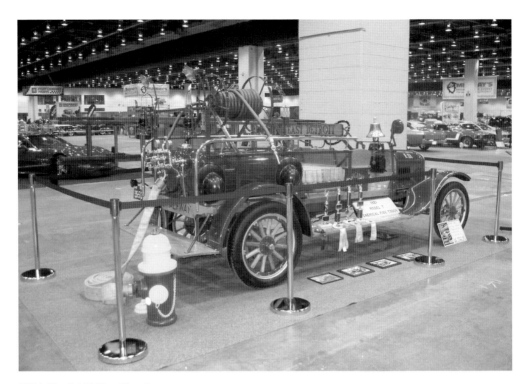

1921 Model T Fire Truck

The Crescentwood Toepher Citizens Group purchased the 1921 Model T fire truck to help farmers and businessmen combat fires in the township. It was given to the Village of Halfway when it was organized in 1924 and has been with the fire department ever since. It was recently completely restored as a joint project of the Eastpointe Fire Department and the East Detroit Historical Society. It is pictured here when it was entered in the 2008 Detroit Autorama, where it won several first- and second-place ribbons for its restoration and its showing in Best in pre-1929 Class. (Courtesy of Eastpointe Fire Department.)

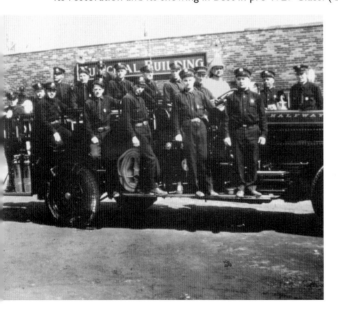

Halfway Fire Department

The Halfway Fire Department is pictured here in 1927, when it moved into the new Municipal Building on Nine Mile Road. The occasion for the photograph is the recent purchase of the LaFrance engine, which was the first department vehicle capable of pumping large amounts of water. An engineer and chief engineer (John Kere and Jesse Hammer) were chosen to work 12-hour shifts to maintain the pumper function. The fire chief at the time was Henry Hauss, supported by Capt. August Zado, Fred Eschman, Lt. Hugh Zienert, Jacob Schany, Marvin Corey, H. Omer Justin, Elmer and Donald Fouchia, August Wychsland, Fred Reder, Ralph Lehman, and Carol Koester. (Courtesy of Eastpointe Fire Department.)

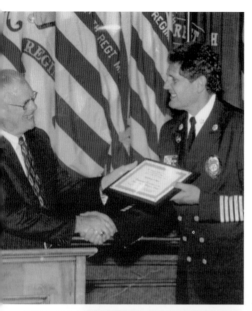

Chief Danny Hagen

Eastpointe Fire Chief Danny Hagen was awarded the Governor John B. Swainson Award in 2009. The Michigan Historical Commission presents the award on an annual basis to public employees who make significant contributions to preserving Michigan's history when such actions are outside of their normal job responsibilities. Hagen was cited by the commission for his role in preserving, restoring, interpreting, and publicizing East Detroit/Eastpointe's original 1921 Model T fire truck. Michigan historical commissioner Tom Truscott is shown presenting the award in the Michigan capitol rotunda. At the same time, Hagen was recognized and presented a State of Michigan Commendation from state senator Dennis Olshove and state representative Harold Haugh, signed by Michigan governor Jennifer Granholm. (Courtesy of Michigan Historical Commission.)

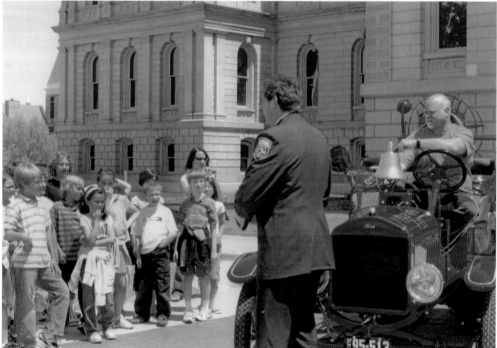

Firefighting History

Educating schoolchildren about the history of firefighting was one of the purposes of restoring the 1921 Model T fire truck. While the truck was on the capitol steps for the John Swainson Award, a group of touring schoolchildren happened to drop by. Spontaneously, Chief Hagen went into action, talking to the kids about all of the features of the 1921 Model T, how the chemical tanks were used, and how different it was to fight field fires in the 1920s versus building fires in the 21st century. (Courtesy of Michigan Historical Commission.)

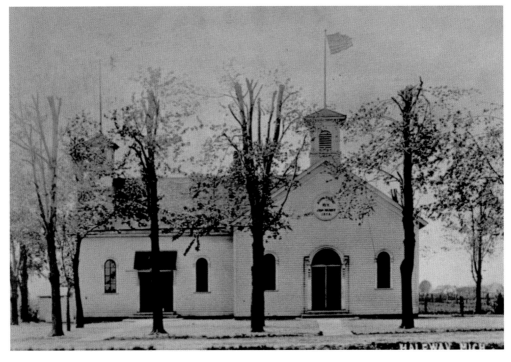

Halfway Schoolhouse

The Halfway Schoolhouse Restoration Team used this 1900 photograph of the Halfway Schoolhouse as they planned the rehabilitation of the 1872 building. The team consisted of volunteers who worked on fundraising, teachers who assisted with first-person oral histories of former schoolhouse students, and high school and adult education students who worked on the restoration of the windows and various wood features. (Courtesy of the East Detroit Historical Society.)

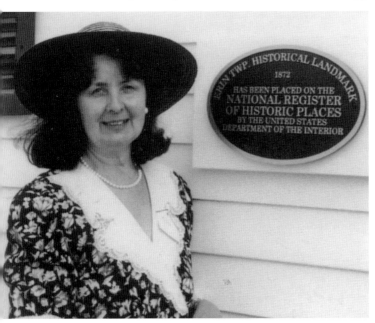

Schoolhouse Dedication

The East Detroit Historical Society felt it had accomplished its restoration goals when the Halfway Schoolhouse was recognized not only by the State of Michigan with a historical marker, but also by the US Department of Interior, which placed the schoolhouse in the National Register of Historic Places. Darlene Sue Young is seen here on Dedication Day following the completed restoration. Today, the schoolhouse is regularly used for meetings of the society and other historical groups, open houses for residents, and classes for grade-school students. (Courtesy of Darlene Sue Young.)

CHAPTER TWO

Writers and Journalists

Reading maketh a full man, conference a ready man, and writing an exact man.

—Sir Francis Bacon

Two of the most popular classes at the local high school have always been journalism and creative writing. There are hundreds of residents who successfully completed these classes. Many have become local newspaper writers and journalists, but most have left the state and enjoyed successful careers with large papers. While it is reported that many residents have written fiction or nonfiction books, none of these writings have found their way to the local library or data banks. Why is that? The talents are here, as are the educational opportunities, yet few have accepted the challenge. This chapter focuses on a few who published and attempts to show the variety of possibility.

Leo LaLonde

Sp4c. Leo LaLonde received an Army Commendation Medal in 1971 for meritorious achievement while assigned as a journalist to Headquarters US Army, Fort McNair. During a six-month period, the publication of the Military District of Washington (MDW) Post won two US Continental Army Command Copy Desk Awards, including one for technical improvements and several plaudits for journalistic excellence. The citation reads, "his distinguished performance of duty contributed to Army journalism and reflects great credit upon him, the Washington Military District and the US Army." In 1972, the same MDW post, under LaLonde's editorship, was the recipient of the 1972 Keith L. Ware Award for the best command newspaper within the US Army. In subsequent competition, it received an even greater accolade, the Thomas Jefferson Award for the best authorized newspaper within the Department of Defense, worldwide. The judging was by a civilian panel from Copley newspapers, the sponsor of the Jefferson Award. Later in life, LaLonde was elected twice to represent the City of Eastpointe as a Michigan state representative. Following that, he had a long career working with the Michigan Prison System, retiring in 2011. (Courtesy of Leo LaLonde.)

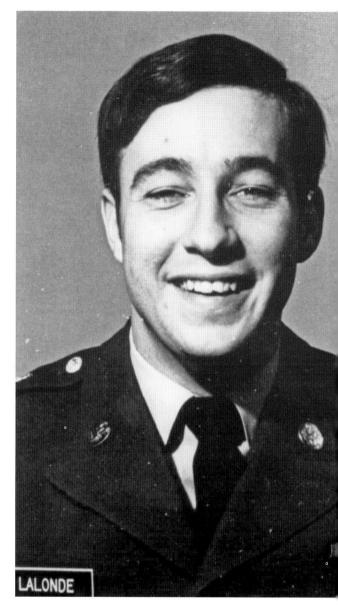

LALONDE

John Enwright

Enwright began teaching history and journalism at East Detroit High in 1947, continuing through 1970. Originally from Marquette, he graduated from Northern Michigan University and then was drafted during World War II. He served as a staff sergeant with the 42nd Division as it advanced through Northern Europe. Enwright, pictured here at upper left, was taken prisoner by the Germans during the Battle of the Bulge and held until the end of the war. Returning to the United States, he went back to school, earning an MA in journalism from New York's Columbia University before accepting a position at East Detroit. As advisor to the school newspaper, *The Shamrock*, and the yearbook, he saw both groups win multiple Press Association awards at local, regional, and national levels. Many of the articles and columns written by his students found their way into publications as examples of good journalism. In 1949, he started a variety show, *Shamrock Shenanigans*, in which students sang, danced, and acted out some of the most recent Broadway plays. Later, he worked with band director Al Marco to develop original overtures and finales of all the music with that year's Shenanigans. Enwright always achieved his primary goal, which was to increase the involvement of large numbers of students, developing hidden talents and building self-esteem along the way. Following his unexpected death in 1970, the high school auditorium was named the John Enwright Auditorium and a memorial plaque was placed next to the main entrance. (Courtesy of the East Detroit Historical Society.)

Carl Middledorf

Carl Middledorf came to East Detroit as the principal of St. Peter's Lutheran School. He believed very strongly in family support, insisting on parental involvement as key to a student's academic success. Under his guidance, graduates of the school reached high academic levels, with most pursuing college degrees and careers in science, teaching, and law. Many have returned to the school to teaching positions. During this time, he also became keenly aware of the church and school's historical background, which dated to the 1840s. He worked diligently on the monumental task of gathering information, pictures, and data that was buried in old church and cemetery records. Many of these records were in old German, which required a specialized translator. After retirement, Middledorf authored two books, one on the history of St. Peter's Church, and the second on the history of St. Peter's Lutheran School. These contain an amazing amount of information, including genealogical records of baptisms, confirmations, weddings, and deaths. Since St. Peter's is one of the two oldest churches in the city, reading these two books is like reliving the area's history. (Courtesy of Carol Middledorf.)

Carl Middledorf's Woodcarving

Woodcarving is a rare, painstaking art form that blends artistry, creativity, and manual dexterity. Carl Middledorf was one of the local woodcarvers, known for his work with items as small as wooden seals to larger, more intricate designs like manger scenes, wall carvings, and statues. He carved many items for his church and family. One of his wife's favorites is this regulator clock that he made for her. Many of the features of this clock are testimony to his German background. Another of his pieces was a spinning wheel, which he surprised his wife with one Christmas morning. (Photograph by the author.)

Macomb Daily photo by Bob Sassanella

Dedicated

East Detroit Halfway Schoolhouse was dedicated ently with the placement of the roundel on the nt of the school. The roundel, developed by St. er Lutheran School Principal Carl Middledorf, left, shows the school was founded in 1872. Middledorf is flanked by Dr. John Gardiner, East Detroit Public Schools superintendent and the driving force behind the renovation of the schoolhouse.

The Roundel

Community service was also part of Carl Middledorf's life. When the restoration team began work to bring the Halfway Schoolhouse to its original state, Middledorf volunteered to make the roundel that had been affixed to the front of the building. Shown here are East Detroit Public Schools Superintendent John Gardiner (right) and Middledorf as the restoration was completed. Middledorf later made a bell hanger with casters, which holds the original schoolhouse bell in place but allows it to be moved within the building for demonstration purposes. (Courtesy of the East Detroit Historical Society.)

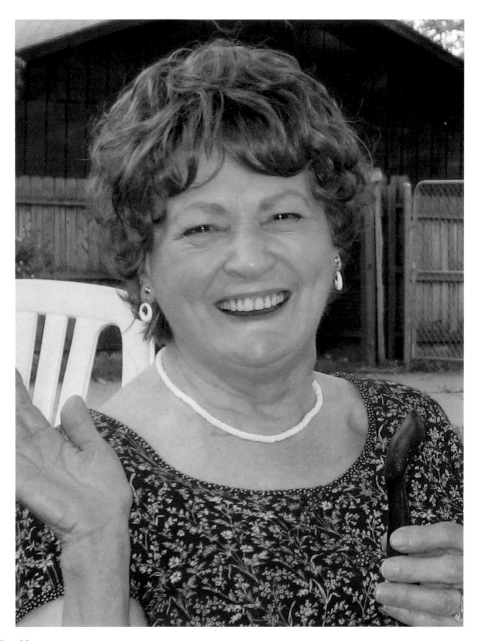

Meg Humes
Humes had a passion for Detroit history, cooking, teas, and teaching. There is probably no one except Humes who could turn this combination into a final product. As the president of the Detroit Historical Society Guild, it was her idea to collect recipes, pictures, and drawings depicting the cooking habits of 300 years of Detroit history. With the help of Shirley Hartet and Rennie Hughes, the guild published *Celebrating 300 Years of Detroit Cooking, 1701 to 2001,* to celebrate the guild's 50th anniversary of service to the Detroit Historical Society and Museum. Following the book's publication, Humes filled her busy schedule with book lectures and demonstrations of many of the included recipes, the latter often requiring her to find items such as squirrels, muskrats, and possums for the cooking—and the tasting. (Courtesy of Bill Schwedler.)

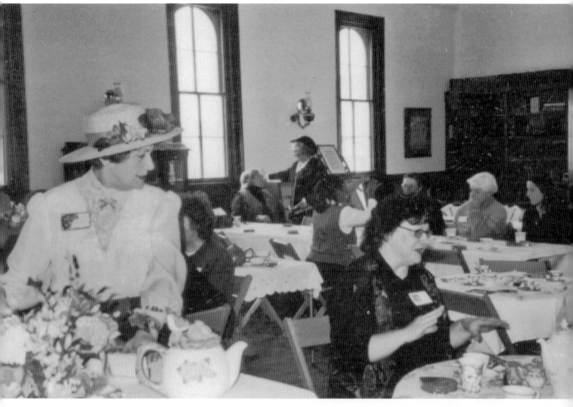

Meg Hume's Teas
Tea and etiquette were two subjects that Meg Humes loved to teach. A frequent presenter at area historical societies, she spoke about the different kinds of tea, the etiquette that was part of the formal tea, and, for the children in the group, something about proper manners. She loved to dress according to the period in history she was covering, and was always seeking out clothing typical of different eras. She is shown here at the East Detroit Historical Society speaking about teas of the Victorian period. (Courtesy of the East Detroit Historical Society.)

George Lawroski

George Lawroski will go down in local history as the person who changed the whole tone of East Detroit/ Eastpointe. His major efforts to change the name of the city from East Detroit to "something else" led to three ballot issues, each with a different potential name for the city. In the final election, which was held in August 1991, a low percentage of registered voters turned out. Nevertheless, the electors voted to change the name of the city from East Detroit to Eastpointe. Following that election, Lawroski wrote and self-published a 37-page book in 1992 entitled *The Eastpointe Story: A True Account of Vicious Small Town Politics During a One Man Campaign to Change a City Name.* At the same time, the newly named Eastpointe set about the task of changing all of the signs throughout the city, including this one at Ten Mile Road and Gratiot Avenue. (Courtesy of Mrs. George Lawroski.)

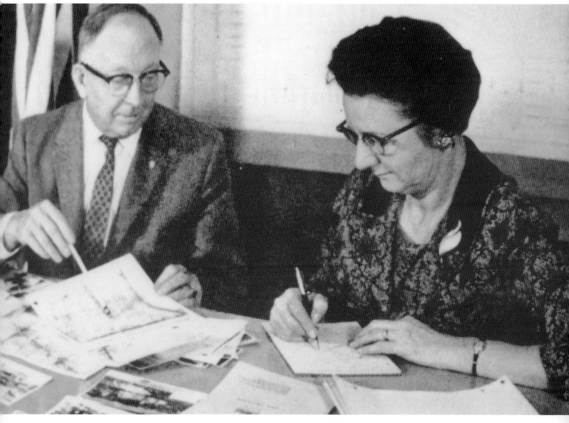

Robert S. Christenson

Robert Christenson was the East Detroit High School principal from the year it opened, 1930, until he was promoted to the director of secondary education in 1959. He retired in 1963 after 33 years of service. During his career, the school achieved high levels of academic and athletic success. Christenson was an avid historian, kept fastidious records, and was an accomplished writer. Until he wrote *The Halfway–East Detroit Story* in 1962, no other book had been published to record the area's history. While he acknowledged the fact that the book would no doubt overlook some incidents and facts, he felt that it was critical to record something rather than wait. Shown here is Christenson with his longtime secretary, Helen Raybaud. In 1979, a revision of the book was completed by The East Detroit Historical Society in recognition of the 50th anniversary of the City of East Detroit. That edition, which was edited by retired principal Carroll Bratt and former East Detroit finance director Esley Rausch, extended the data of the original book, documenting facts that would otherwise be lost to time. (Courtesy of the East Detroit Historical Society.)

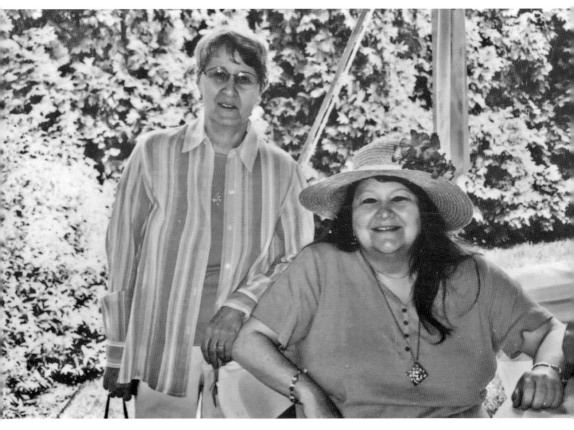

The Jackson Sisters
Kathy (left) and Dana Jackson are East Detroit High School graduates who decided to try their hand writing for a large city newspaper. Kathy began working in the television department of the *Detroit Free Press*, covering show times, schedule changes, and feature stories associated with the programming. Later, her younger sister Dana joined her, working in various departments. For many years, Dana was the force behind the articles in the *Eastside Community News*. This was her favorite assignment, as she enjoyed the personal-interest and feature stories of the suburban areas. Although she frequently interviewed celebrities, her favorite interviews were with artists in Detroit's music scene and the blues musicians who came to Detroit-area festivals. (Courtesy of Sue Young.)

CHAPTER THREE

Artists, Entertainers, and Educators

Use what talents you possess:
The woods would be very silent if no birds sang there except those that sang best.

—Henry Van Dyke

There are many outlets in Eastpointe through which a resident can pursue arts, music, and education. Occasionally, achievers in these fields have crossed over from one area to another. A football coach or athletic director is no less an educator than the classroom science teacher. A band instructor may be extremely talented in regards to musical performance, but equally talented in sharing his knowledge with future performers. This chapter highlights a chosen few who have excelled in the areas of education, art, and entertainment. Their accomplishments are varied, but equally impressive.

Al Asbury

Al Asbury may have gone to high school in West Virginia, but there is no denying that he considered himself an East Detroit Shamrock. He spent 30 years at East Detroit High School, leaving his mark in so many ways, not the least of which was as a highly successful football coach. In nine seasons at East Detroit, he compiled a 40-29-8 record, including an undefeated 9-0 1956 season that saw the Shams win their first Eastern Michigan League (EML) title. That year, he was named Macomb County Coach of the Year. Beyond the win-loss record, Asbury coached some of the finest players in EDHS history. Among them were four future professional football players. In 1957, he became a full-time counselor at the high school, devoting a great deal of time to the guidance program. In 1964, he became assistant principal, a job he held until his 1978 retirement. In 1976, Asbury was named East Detroit Citizen of the Year. (Courtesy of the East Detroit High Athletic Hall of Fame.)

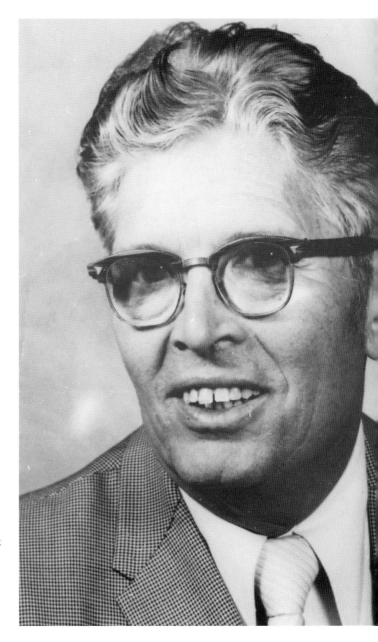

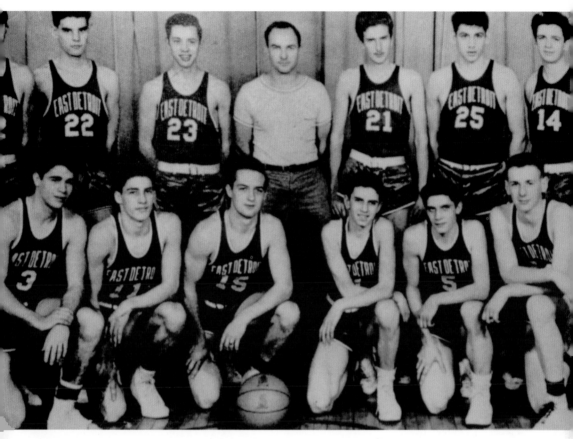

Fred Lee

Fred Lee served East Detroit High School and its athletic department for 28 years. His early coaching assignments included junior varsity football, varsity baseball, and of course, varsity basketball. He was appointed athletic director in 1958, serving in that role until his retirement in 1978. He is most remembered for the varsity basketball teams from 1946 to 1966. During that time, his teams won six league championships and six district championships. Four of his teams won regional titles and reached the quarterfinals, with two teams playing in state semifinals. Lee (second row, center) poses here with the 1950 team. He was selected Macomb County Basketball Coach of the Year in 1958 and again in 1966. The Basketball Coaches Association of Michigan selected him as Michigan Coach of the Year in 1966, as did the *Detroit News* and *Free Press*. He was recognized by his peers when he was inducted into the Michigan School Coaches Hall of Fame in 1976. (Courtesy of the East Detroit Historical Society.)

Mel McKenzie

Any time East Detroit High baseball is brought up in conversation, Mel McKenzie's name is not far behind. McKenzie coached for 29 of his 38 years with the East Detroit School District, 27 of them as head baseball coach. During that time, the Shams compiled a 307-184 record, for a .625 winning percentage. His teams won nine EML championships. He was nominated for National Coach of the Year in 1979, was District Coach of the Year in 1988, and coached in the East West All-Star Game that year at Tiger Stadium. In 1994, McKenzie was inducted into the Michigan High School Baseball Coaches Hall of Fame, and in 1999, he was inducted into the Macomb County Coaches Hall of Fame. (Courtesy of East Detroit High Athletic Hall of Fame.)

Ron Ruzzin

Ron Ruzzin is one of the few people who played sports at East Detroit High and then returned to the school as an educator. In Ruzzin's case, he was initially a teacher, then a coach, and finally an athletic director before retiring. During his 1946–1949 student days, he earned nine letters, three each in football, basketball, and baseball. He was captain of the football and baseball teams and was recognized as second-team All State in football. He played football at Eastern Michigan University, where he earned All-League honors. When he returned to East Detroit, he taught and coached first at Oakwood Junior High School, then transferred to the high school, where he became the head football coach in 1962. He held that position for 16 years. Ron's Shamrocks won six EML championships, and he was named Regional Coach of the Year in 1976 after the Shams went 8-1. He was named athletic director in 1978, overseeing the rapid growth of the female athletic program. Ruzzin was inducted into the Macomb County Coaches Hall of Fame in 1995. (Courtesy of East Detroit High Athletic Hall of Fame.)

Christine Schneider and Larry Andrewes

Christine Schneider's East Detroit School career is intertwined with the growth of girls' sports. She coached the first girls' swim team in school history in 1972, and the first girls' basketball team in 1975. She spent 35 years in the district as a teacher, coach, athletic director, assistant principal, and mentor to many. The Shams won one conference title and two district titles in her eight seasons coaching basketball. But it was in softball that she made her mark, with 442 wins and 209 losses with six league titles, six district championships, four regional crowns, and three times as state runners-up in class A. She was Macomb County and Suburban Coach of the Year in basketball in 1982, District and Regional Coach of the Year in 1987 and 1996, *Detroit Free Press* Coach of the Year in 1980, and three-time Macomb County Coach of the Year. She was inducted into the 1997 Macomb County Coaches Hall of Fame and the Michigan HS Softball Coaches Hall of Fame in 1998, and in 2001, she was named to the Michigan HS Coaches Association Hall of Fame. She was inducted into the East Detroit Hall of Fame in 2005. From 1975 to 1985, Larry Andrewes served as the varsity girls' track, cross country, and assistant boys' track coach at East Detroit High School, compiling an impressive 160-45 record. His teams won six league titles and a regional girls' track crown, and he coached one state-finalist cross country team. His girls' track teams won 30 consecutive dual meets between 1982 and 1984. In 1985, Andrewes took over as the EDHS athletic director, a position he held until retiring in 1998. He was awarded the Allen Bush Award, given by the Michigan High School Athletic Association in 1995, for dedication and service. In 1997, he was named the Region 10 Athletic Director of the Year. Before arriving at the high school, Andrewes coached seventh grade boys' basketball and track at East Detroit's Grant Junior High School for six years. Previously he coached boys' track at Roosevelt High School in Ypsilanti, Michigan. (Courtesy of Larry Andrewes.)

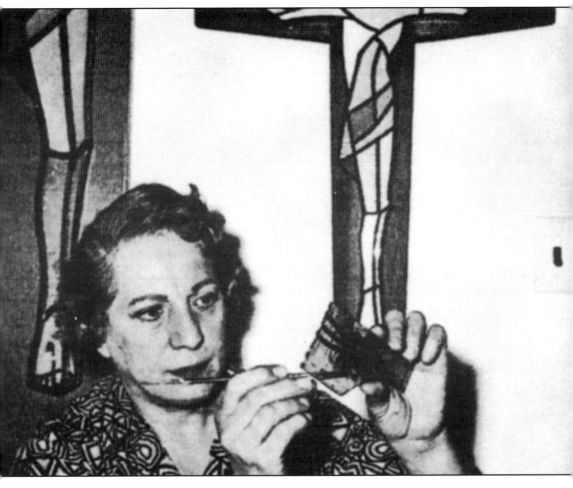

Mary Giovann

Giovann, an East Detroit resident, was immersed in many facets of the creative arts. After her early education at St. Mary's Academy in Monroe, Michigan, she studied art and drama at Detroit's Cass Tech, followed by art training at Wayne State University and the Society of Arts and Crafts (now the College for Creative Studies). She spent one year as an apprentice at the Bleecher Manikin Studio, gaining experience in clay modeling and casting. Giovann was director, actress, and set designer for plays performed at the DIA, organized a puppet theater, taught music and arts and craft classes for the League of Catholic Women's Weinman Center, and supervised the JL Hudson Co. art supply department. She designed numerous windows for the Detroit Stained Glass Works. Many of her pieces were marked by stylized designs and strong colors. The works found on the next few pages illustrate the versatility of this great artist, from the traditional religious stained-glass windows found in St. Veronica Convent to the abstract, symbolic designs of the nave windows of St. Veronica Catholic Church. Giovann not only designed the windows, she also worked with Jim Cramer to cut and lead them. (Courtesy of Sue Young.)

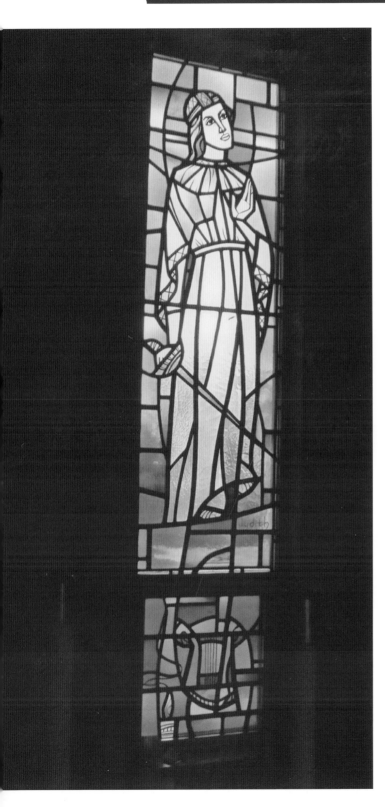

St. Veronica Window
Mary Giovann's interpretation of the Old Testament character of Ruth conveys the story of the widow who gleaned leftover barley in the fields to take to her mother, Naomi. This window was created for the St. Veronica Convent in 1965. Recognizing Giovann's artistry in the St. Veronica Catholic Church and Convent stained-glass windows, parishioner Darlene Sue Young and photographer Robert Brown collected information related to the interpretation and window designs, photographed the collection in detail, and successfully registered the collection in the Michigan Stained Glass Census at Michigan State University in March 2009. (Photograph by Marco Catalfio.)

St. Elizabeth Window
Contrasting examples of stained-glass design by Mary Giovann are offered by the two photographs on pages 42 and 43. The one on this page is a traditional religious reproduction of a biblical story describing St. Elizabeth. This is one of four designs found in St. Veronica Convent that depict the stories of "The Valiant Women." (Photograph by Marco Catalfio.)

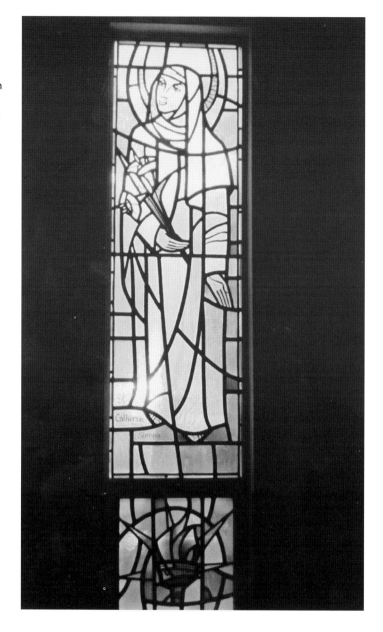

The Mary Window (OPPOSITE PAGE)
In contrast to the traditional piece on this page, the two windows shown opposite depict the Virgin Mary. When the windows were dedicated, Monsignor Edward T. Burkhardt stated, "It is hoped that these windows will express ancient themes in a way that will continually stir the imagination and enrich the fate of generations to come. To put it another way, it is hoped that these windows will never be taken for granted, that they will constantly communicate life and movement and the dynamic character of our faith." (Photograph by Marco Catalfio.)

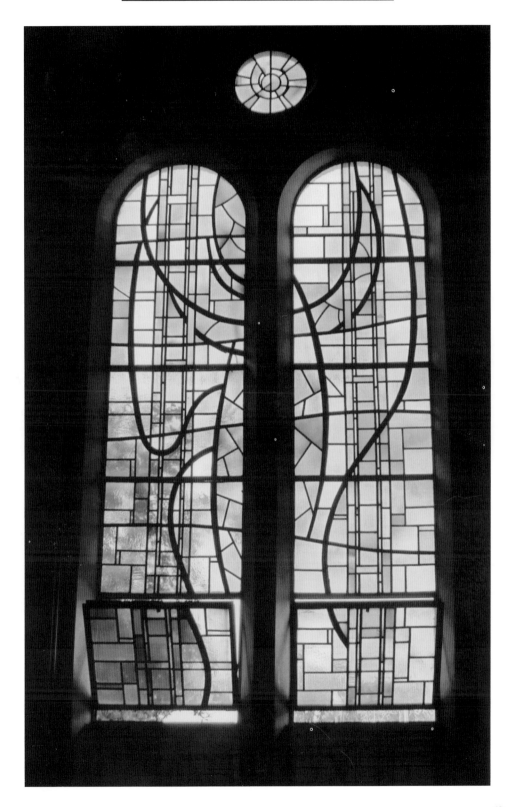

Darlene Sue Young

While her six children were still young, Darlene Sue Young became part of a group called Picture Lady. Once a month, she and eight other mothers would select an artist, representing a distinct style and technique, and would visit classrooms of local schools to do a half-hour presentation about the artist of the month. What started as a temporary way to help young children appreciate art turned into a 20-year labor of love. Looking back on the project, Young is quick to say that while the children learned something new, it was she who gained a deeper knowledge of the famous artists of the world. Much to her dismay, Picture Lady was terminated by the picture supplier as "unworthy of the time involved." (Photograph by Marco Catalfio.)

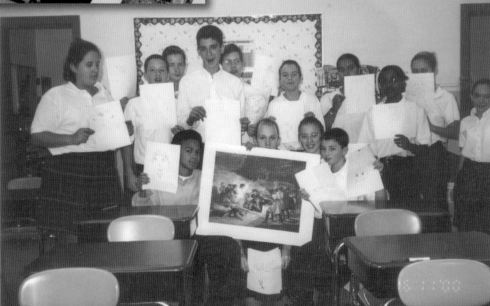

Picture Lady

Classrooms of kids eagerly awaited the monthly arrival of the Picture Lady. Excitement surrounded the mystery of which artist would be discussed that month and what type of special activity would be included with the visit. Here, students show their budding artistic attempts to replicate one of the faces in the artist's picture. (Courtesy of Sue Young.)

44

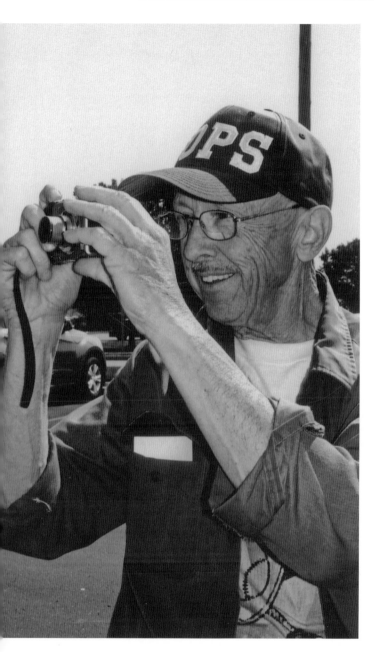

Robert Brown

Robert Brown is Eastpointe's unofficial, self-appointed photographer. After he retired from an automotive plant, he found himself with little to fill his time. On a whim, he bought a small digital camera and began to ride around the city, snapping photographs of local Eastpointe scenes. He can be found with his camera at official events, festivals, and parades. Brown asks for no compensation, but simply enjoys capturing the pulse of the city. A large collection of his photographs from the past year is available for viewing in the lobby of the Eastpointe City Hall. His eye for capturing detail and using different camera angles is amazing. Many of Brown's photographs have been used by the Eastpointe Roseville Chamber of Commerce in its marketing materials. (Photograph by Marco Catalfio.)

Melissa Knobloch
An East Detroit High graduate who found her niche in art, Melissa Knobloch received a number of awards while in high school and was highly recommended for a college art scholarship. She continued to excel at Michigan State University, again receiving a number of awards. Knobloch was accepted into the San Francisco Institute of Arts, where she completed her master of fine arts. One of her first jobs following graduation was working to create a children's museum in San Diego. After the museum opened, she switched to corporate work, but still pursues contemporary art, with special exhibits in the San Diego area. (Courtesy of Gregg Knobloch.)

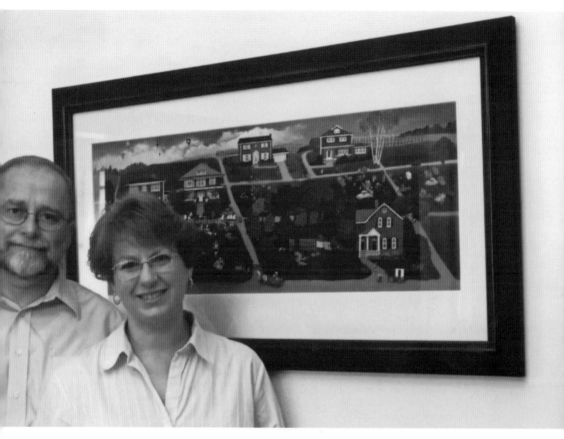

Marcie and Jerry Rochon

Jerry Rochon received a BA in fine arts from Wayne State, which allowed him to work with his father, Richard, as an architectural illustrator. As computers replaced artistic renderings, Jerry returned to school for a master's degree in art education and now works as an art instructor, teaching K-12 at two parochial schools. In his spare time, he can be found sketching sculptures at the Detroit Institute of Arts. Marcie earned an associate's degree in graphics and commercial art at Macomb Community College and began teaching portrait painting in pastels through various local recreation programs. Her experience as a graphic artist gave her opportunities to work for television, creating storyboards, writing scripts, and designing sets. She continues to teach various forms of art, but loves folk art. Shown here is her rendering of the Village of Halfway, showing local homes and a barn. The Rochons are parents of one daughter, now a junior in a New Hampshire college, and three sons. The children are of course interested in all aspects of art, from photography and architecture to cartooning, animation, and sculpting. (Photo by Christopher Rochon.)

Al Marco (OPPOSITE PAGE)
Al Marco is the music director who comes to mind when anyone mentions East Detroit High band or choir. He graduated from a small college in Indiana, Pennsylvania. At the urging of his peer group, Marco decided to expand his band education, and chose to go to the University of Michigan for a master's degree in music education. He played drums in Michigan's marching band under the direction of the all-time great, Dr. William Rivelli. He was then hired at East Detroit in 1956, spending the next 35 years in the music department, 24 years with the bands and another 11 with the choirs. He worked closely with the middle school band instructors to increase participation and to develop a high quality of performance. The bands won many top performance awards, including being placed on the coveted John Phillip Sousa Foundation's Historic Roll of Honor of High School Concert Bands for the period between 1960 and 1990. This roll of honor recognizes bands of very particular musical excellence. After reviewing 320 band programs nationwide, the foundation chose East Detroit High and Marco as part of the group of 61 high school bands and 63 band directors. Today, even in retirement, he continues to be involved in music, playing gigs in Michigan and Florida. (Courtesy of Al Marco.)

Gabe Villasurda
Gabe Villasurda started in East Detroit High as one of Al Marco's tuba players in the marching band. He ranked first out of 452 students in the graduating class of 1959, and was class valedictorian. He easily won a music scholarship to the University of Michigan, where he earned a bachelor's degree in music education with high honors in December 1963. While at Michigan, he played the tuba in the marching band and took part in the university's Russian concert tour of 1961. While in Russia, he was exposed to many of the Russian string festivals and became intrigued with the violin and viola. Returning to the United States, he studied violin with Gustave Rosseels and conducting with Elizabeth Green and Theo Alcantara. Later, he earned a master of music degree. He has taught in the Ann Arbor Public Schools, the American School in London, and the Punahou School in Honolulu. During the summers, he taught at the Interlochon Arts Camp for a 35-year span. Today, he is a fully certified Suzuki violin teacher. He has done studio and group teaching in England, Holland, and many US states and has conducted numerous clinics and adjudications in Michigan and Ohio. (Courtesy of the East Detroit Historical Society.)

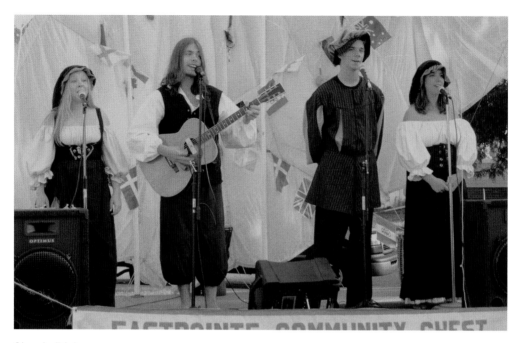

Simply Dickens

Simply Dickens was formed in 2001, when 13-year-old Tom Giorlando (second from left) and 14-year-old Kourtney Weishaupt (right) came together to rehearse Christmas music for the Holly Dickens Festival. Bored with the same old Christmas music heard repeatedly on the radio and in malls, the duo decided to do something different, and developed a set list of old world Christmas music, including songs such as "The Gloucestershire Wassail" and "Bring a Torch Jeanette Isabella." They were quite a hit among the festival attendees and were asked to return the following year, and have gone back every year since. It was Kourtney who came up with the name Simply Dickens, as the group performed mainly at the Holly Dickens Festival. Also pictured above are Kat Schank (left) and Max Finley (second from right). (Courtesy of Ken Giorlando.)

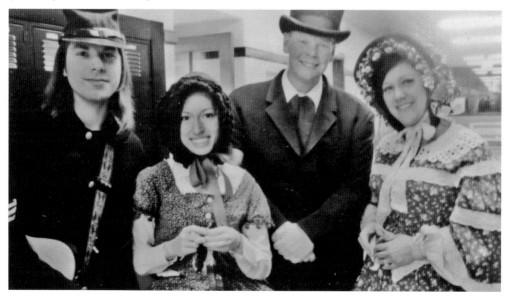

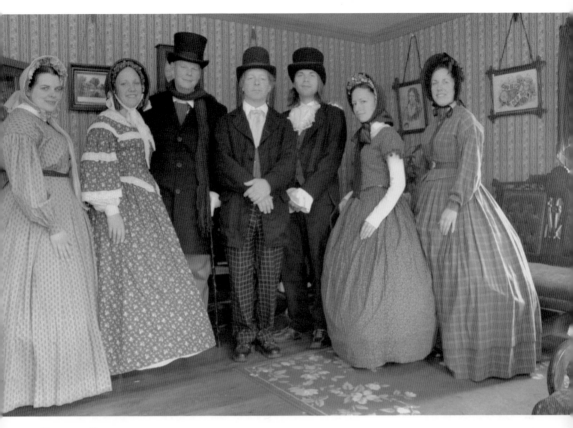

Current Group

The current incarnation of Simply Dickens still consists of Eastpointe resident Tom Giorlando and Eastpointe art teacher Diane Moses, and now includes Kim Parr, Tom Campbell, and Samantha Yagloski. The group's repertoire continues to expand, and it has added skits and song introductions by Tom's father, Ken, as well. The audience response to the group continues to be overwhelming. Simply Dickens continuously performs for schools, historical societies, festivals, reenactments, benefits shows, and even at Greenfield Village during holiday nights. In its 11 years of existence, the group's membership has grown from two Eastpointe middle school students to several adults, varying in age from 21 to 51. Pictured from left to right are Heidi Neiderer, Diana Moses, Tom Campbell, Ken Giorlando, Tom Giorlando, Samantha Yagloski, and Kim Parr. (Courtesy of Ken Giorlando.)

Expanding Repertoire (OPPOSITE PAGE)

Simply Dickens expanded into a quartet by Christmas 2004. The group played various festivals that year with not only a changed membership but an expanded repertoire, which included a German version of "Silent Night," the Colonial-era "All You that Are Good Fellows," and even the Spanish madrigal "Riu, Riu Chiu." That year, they also began to play at Civil War reenactments, performing 19th-century songs such as "Faded Coat of Blue," "Shady Grove," "Some Folks Do," and "Just Before the Battle Mother." (Courtesy of Ken Giorlando.)

Dan Zander

One of the many locals who form the community's backbone, Zander has been a crossing guard for over 20 years, assisting elementary school students across crowded intersections. Rarely does he miss a beat. You will find him riding his bike through rain, snow, and sleet to his designated corner. As students grow up, marry, and have children of their own, they often return to Dan's corner to say hello and remind him of the times he helped them. Rarely does Dan forget a name or a face. He is involved with the schools, offering to say the invocation at each of the East Detroit School Board meetings and occasionally at the Eastpointe City Council meetings. He is the only person who gets a designated spot on the school buses heading to the big athletic events. Following these events, Zander will report the scores at the televised school board meetings so that no one in the community misses the game results. (Courtesy of Dan Zander.)

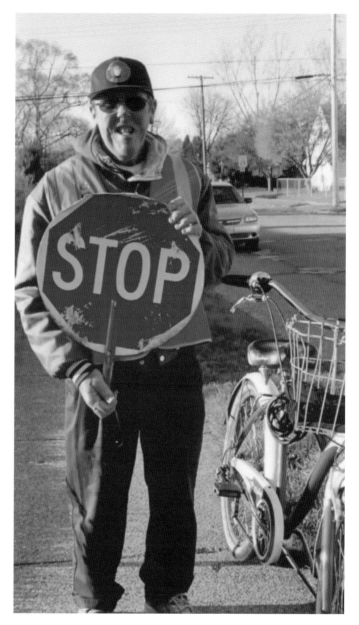

Melody Walters

Melody Walters is a longtime Eastpointe resident who has worked as an IT consultant for a number of companies, doing mostly computer programming and systems analysis. Her true passion, however, is photography. She carries a camera on her belt wherever she goes. Macro photography is one of her favorite shooting styles, and colors are very inspiring for her. She feels it is an honor for her to capture the beauty of nature and the oddities of the everyday. Walters loves to take photographs of nature, landscapes, and buildings and anything else that catches her interest. Many of her photographs appear in this book. (Courtesy of Melody Walters.)

Marco Catalfio

Another talented local photographer, Catalfio gets more excited and improves with each photograph he takes. A new camera, or just a new lens, adds to the thrill of capturing nature, the architectural lines of buildings, and the facial expressions of pets, children, and adults. Photography is a hobby that needs constant updating, and Catalfio attends continuing education classes at Macomb Community College. He admits, though, that he often gains as much insight about techniques by going to shooting assignments with classmates. Many of Catalfio's photographs appear in this book. (Courtesy of Melody Walters.)

Ashley Presson

Presson, an Eastpointe photographer, recently won the National American Visions Gold Medal Award for her photograph, shown here, entitled "Nightmare." In June 2012, the prestigious award was presented to her at Carnegie Hall in New York City. She was one of 15 students nationwide to win this award. Art teacher Veronica Belf was also on hand to receive a gold medal as the student's instructor. (Courtesy of Ashley Presson.)

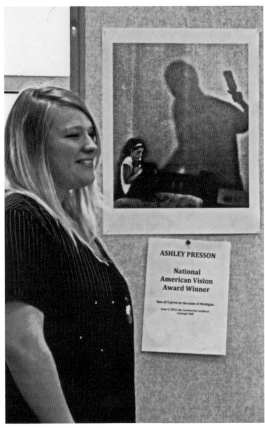

Allison Suwalkowski

East Detroit High photographer Allison Suwalkowski was presented a gold medal at the June Scholastic Arts Awards in New York City. She won in the category of digital photography. Suwalkowski is seen here (center) with fellow student Ashley Prisson (left) and art instructor Veronica Belf following the presentation at Carnegie Hall. (Courtesy of Allison Suwalkowski,)

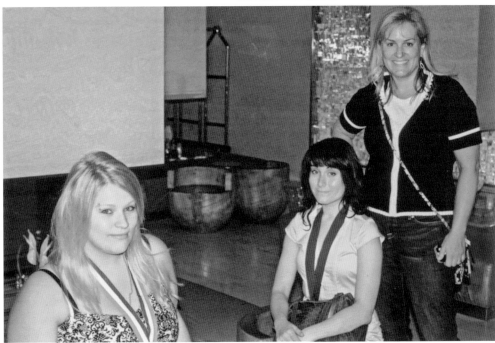

Diana Moses and Veronica Belf
Michigan Week Awards are given out annually by the Eastpointe Roseville Chamber of Commerce to acknowledge notable efforts of various individuals. Recognizing that student art achievements can only happen with strong foundations at the elementary as well as secondary levels, the school administration handed out Educator of the Year awards to Diana Moses (left), at the elementary level, and Veronica Belf, at the secondary level. Despite severe economic cuts, the scope of the art programs has expanded, and a high level of excellence has been demonstrated at both elementary and secondary levels. (Courtesy of Diane Moses.)

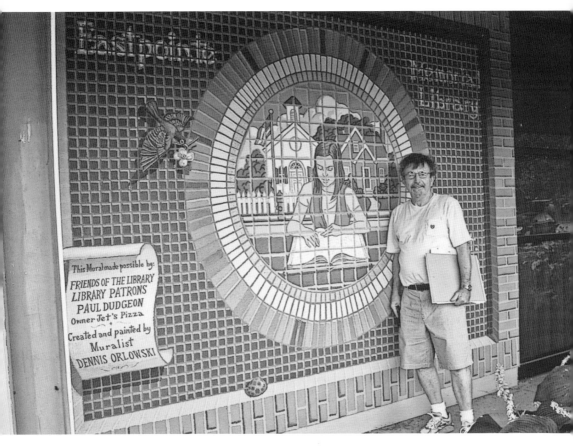

Eastpointe's Memorial Library Mural

The library's new mural is shown here with artist Dennis Orlowski. The project, funded by the Friends of the Library, has been in the planning and implementation stages for several years. The artist donated his time, charging the Friends only for the cost of supplies. Speaking at the dedication, Orlowski claimed that he was a public artist: when he does art, he does it for someone else. He explained that Eastpointe is famous for its residents and for the community as a whole, and that he wanted those elements to be part of what he painted. He included images of the city's famed Halfway Schoolhouse and of a typical ranch home, to show a sense of place. The real message of his work comes from the girl reading in the foreground, showing safety and civilization. Other items included in the mural are the Michigan state bird (robin) and the state flower (apple blossom), as well as the state stone (Petoskey stone). (Courtesy of Dennis Orlowski.)

CHAPTER FOUR

Business Leaders

Develop success from failures.
Discouragement and failure are two of the surest stepping stones to success.

—Dale Carnegie

Eastpointe businesses are the engine of the community. Unlike in larger cities, most of the successful local businesses are of the "mom-and-pop" type, rather than large, corporate-owned big-box stores. Many local establishments have been in business for long periods of time. They focus on dependable products, friendliness, and exemplary customer service. Expensive marketing is not generally used, but word-of-mouth advertising is always successful. The businesspeople featured in this chapter are visionaries, frugal and trustworthy. Many of the businesses are family run—some even contain multiple generations still working together. In their own way, many of these entrepreneurs are local legends.

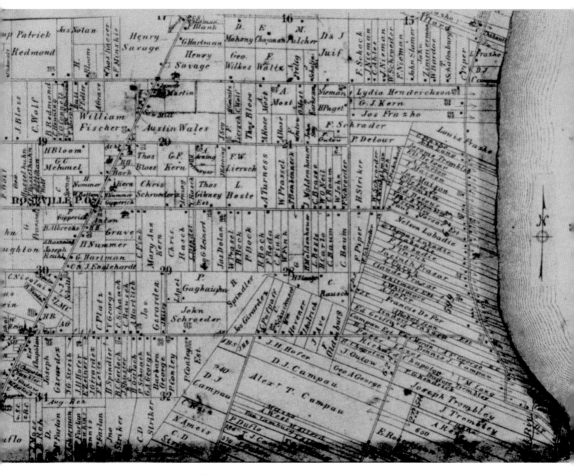

1876 Map of the Southern Tip of Erin Township
Even in 1876, one could see the business section that was developing along Gratiot Avenue and Nine Mile Road. What is now the downtown section of Eastpointe was still largely owned by members of the Charles or August Rein families. While they had branched out into several different types of businesses, their mainstay was still the beloved General Store, located on the northeast corner of Nine Mile Road and Gratiot Avenue. (Courtesy of Eastpointe Memorial Library.)

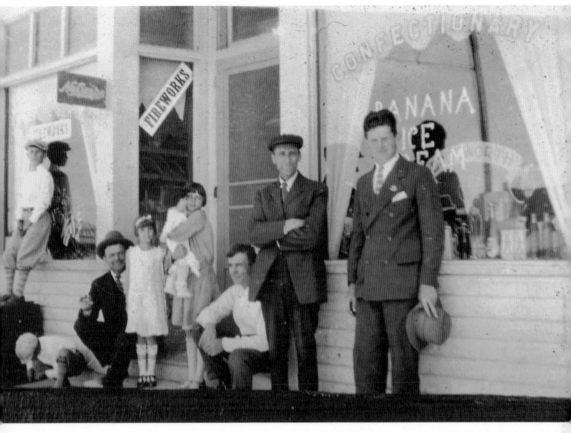

Rein Store

The Rein General Store was one of the most visited establishments in early East Detroit. Based on this 1920s photograph, it looks as though all ages enjoyed stopping by for ice cream. Along with providing essentials, the store was also a popular meeting place. Over the next 50 years, business services would become more specialized, and the ability to supply every need from the shelves of one store would no longer exist. It is amazing to see that fireworks were sold at the same location as ice cream at this time. (Courtesy of the East Detroit Historical Society.)

Karen Semrau Regan
Semrau's Nurseries and Greenhouses was started in 1916 by Karen Semrau's grandfather Robert, a German immigrant. Initially, he grew his vegetable plants outside and in a hothouse and sold them wholesale at Detroit's Eastern Market. He switched to flowers and plants in the 1930s, when the Depression and competition made selling vegetables to wholesalers unfeasible. The retail part of the business gradually evolved after 1950 and now accounts for about 76 percent of the nursery's $1 million in annual sales. Half of the firm's business is done in April, May, and June. May is the busiest month, but December is also busy, when houseplants, poinsettias, and Christmas trees are in demand. Karen Semrau's parents bought the business from her grandfather in 1954. Her father retired at the age of 83, but continued to work half-days. He is now deceased, and the business is managed by his three children. (Courtesy of Karen Semrau Regan.)

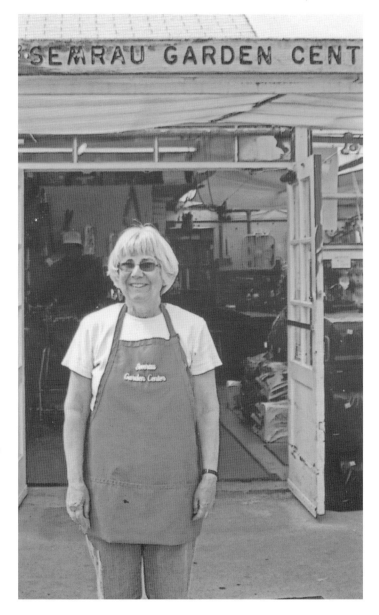

Jim and Dan Semrau (OPPOSITE PAGE)
Jim and Dan Semrau, Karen's brothers, make up the remainder of the Semrau nursery. Their role is to manage the 43,000-square-foot facility, which includes plastic- and glass-covered greenhouses, and a retail shop. Impatiens remains the most popular plant, with petunias number two on the list. Recently, though, Semrau's vegetable plants have attracted many of the area's new home gardeners. Much of the staff is made up of local teens from the high school, some of whom end up working at the location long after college. Several have been with Semrau's for over 25 years. Garden shoppers may find better prices at the big-box stores, but they usually end up at Semrau's for quality plants. (Courtesy of Dan Semrau.)

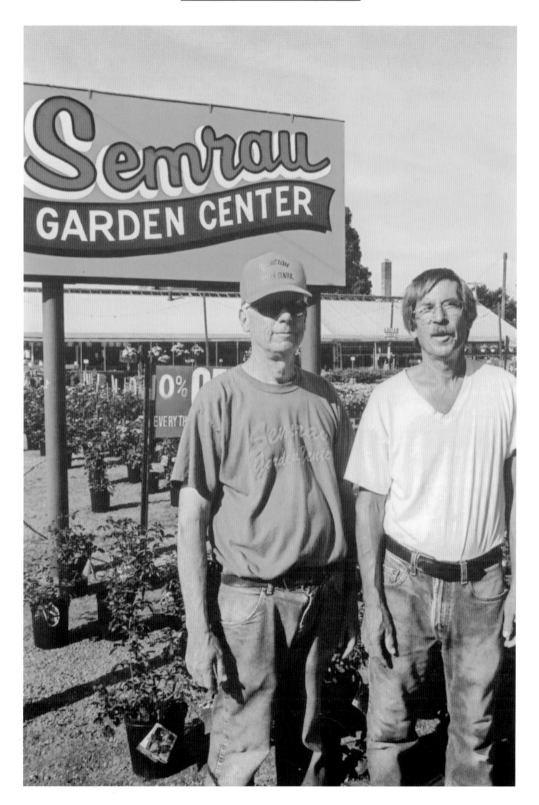

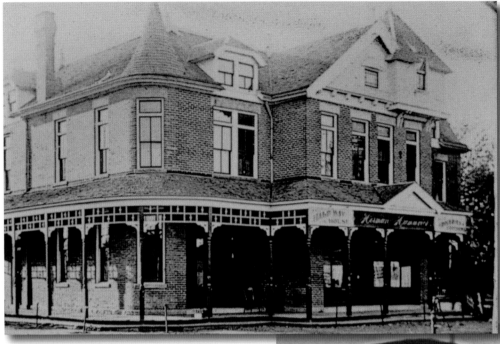

The Halfway State Bank

The Halfway State Bank opened for business on October 20, 1917, with a capital stock of $25,000. The bank was first located in the Hummerich Building (Halfway House) at the corner of Nine Mile Road and Gratiot Avenue. The first officers included August Rein as vice president, George Hummerich and his brother Charles, and three others from outside the city. The bank purchased property on the northeast corner of Gratiot Avenue and Nine Mile Road, where a new building was built and occupied in 1924. When the city of East Detroit was incorporated in 1929, the bank name was changed to the First State Bank of East Detroit. (Courtesy of the East Detroit Historical Society.)

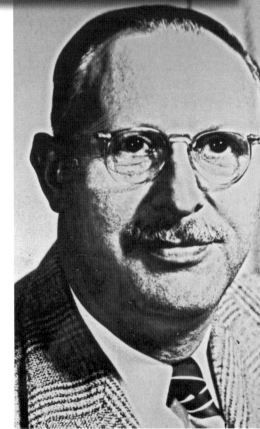

Christian M. Nill

Christian Nill began his business career in the 1920s with a store on Nine Mile Road facing Hayes Avenue. An astute, well-liked businessman, he was easily elected the third mayor of the fledgling city of East Detroit, a position he held from 1933 to 1937. At the same time, when the First State Bank reorganized in 1935, he was appointed to the board of directors. Upon the resignation of the president, Henry Mok, in January 1941, Nill was elected to succeed him. He continued to serve as chairman of the board of directors until his death. (Courtesy of City of East Detroit.)

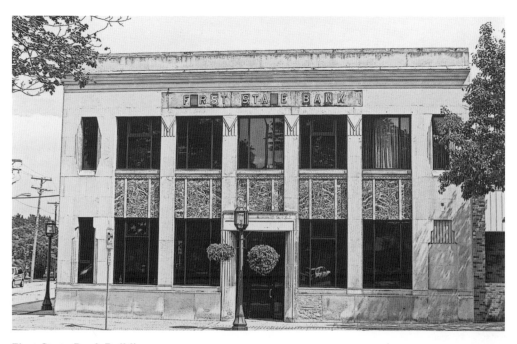

First State Bank Buildings
The widening of Gratiot Avenue in 1930 forced the sale of the original bank building to the state highway department. First State then moved into the building shown here, formerly occupied by the Stephens State Bank. The bank now has many branches, including two in Eastpointe: one at Ten Mile Road and Hayes Avenue, and a second at Nine Mile and Kelly Roads. Its main office in Eastpointe has since moved to the corner of Nine Mile Road and Virginia Avenue. (Photograph by Marco Catalfio.)

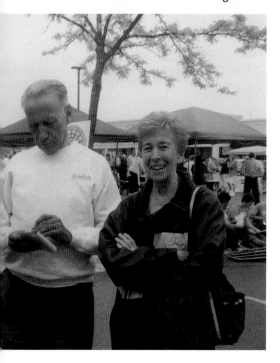

William Nill
William Nill was appointed to the First State Bank board of directors in 1948. In January 1979, he was named president of the bank, a position he held for many years. Nill has always been an integral part of the economic growth of the Eastpointe community. He has served on the Downtown District Authority since its inception in 1985. He has played an active role with the Eastpointe Chamber of Commerce and has supported Eastpointe's Cruisin' Gratiot with large sponsorships, including, recently, a car show held in the First State Bank parking lot. (Photograph by Marco Catalfio.)

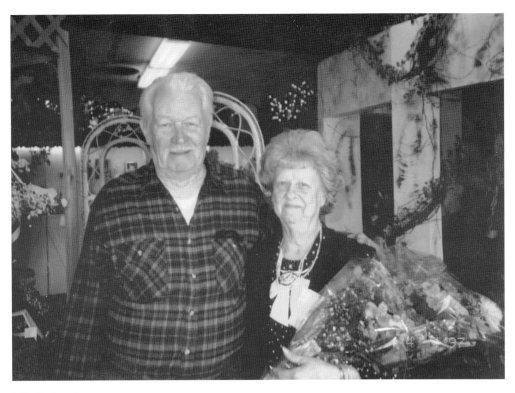

Bill Taylor Sr.
Taylor started his business after designing flowers for another florist in the area. Realizing that he could succeed on his own, he built a store in the 1960s, located on Kelly Road just south of Nine Mile Road. It was a family affair from the beginning, with Bill doing the floral designs and his wife keeping the books and running the retail shop. He was often assisted in the shop by his son, Bill, who eventually took over the business, and his daughter, Michelle, who still helps in the store on weekends. (Courtesy of Michelle Taylor Irving.)

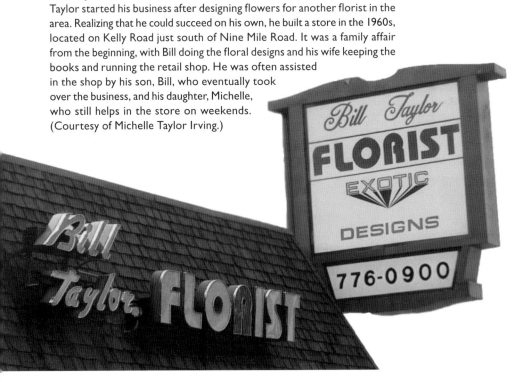

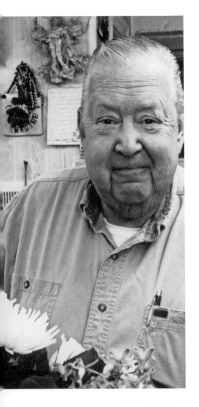

Bill Taylor Jr.

Bill Taylor Jr. is another example of an Eastpointe citizen continuing a family business. Bill, who took over his father's floral business when he retired, continues the traditions of high-quality flowers, unusual floral designs, and quality customer service. Bill has gone one step further, placing an emphasis on community involvement. In the recent past, he has served as president of both the Eastpointe Chamber of Commerce and the Eastpointe Lions Club. At the 2010 Lions International Convention in Milwaukee, Bill was presented with the Lions' highest honor, the Melvin Jones Fellowship Award, for his volunteer work with local hospice groups. (Courtesy of Bill Taylor Jr.)

Hospice Volunteers

The hospice volunteers shown here have been meeting every Tuesday morning for several years. This group breaks down recycled floral bouquets from funeral homes, churches, and grocery stores, taking those that are still of good quality and rearranging them into several smaller bouquets. These are then delivered to hospice patients in hospitals and homes. When Bill Taylor received the Melvin Jones Award in Milwaukee, Lions members attending the convention took the information back to their hometowns, and now similar programs have developed in Florida, California, and South Carolina. Pictured below from left to right are Bill Taylor, Sally Marks, Sally Taylor, Mary Jane Ward, Eleanor Janectal, and Irene Gaca. (Courtesy of Bill Taylor Jr.)

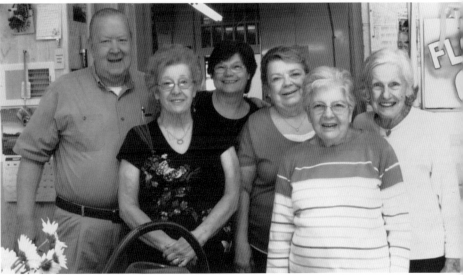

Bill Taylor Florist Shop (OPPOSITE PAGE)

Bill Taylor loved to do what he termed exotic floral designs. His business grew because he would talk to customers to find out exactly what they wanted, and then he would provide that service. He was quick to emphasize to his son as he took over the business that customer service was the most important factor. People came to purchase flowers for special occasions, but often what they were also looking for was a good ear. (Photograph by Marco Catalfio.)

Mario Cercone

Mario Cercone left Abruzzi, Italy, shortly after World War II, going first to Venezuela, where he learned the meat business. He came to the United States in 1954 and opened Mario's Meats in 1967 in Eastpointe's Fairway Shopping Center near Ten Mile and Kelly Roads. There aren't many stores like Mario's anymore. Besides the displayed meats and special orders available at the meat counter, homemade sausages and meatballs can also be purchased. Among the groceries offered are specialty olive oils and pastas, as well as a wide selection of beers and wines. According to Cercone, the store has everything one needs to go into the kitchen. At 80-plus years of age, he still works a half-day, seven days a week and comes out to greet every customer. His store is still one of the most popular in Eastpointe. (Courtesy of Mario Cercone.)

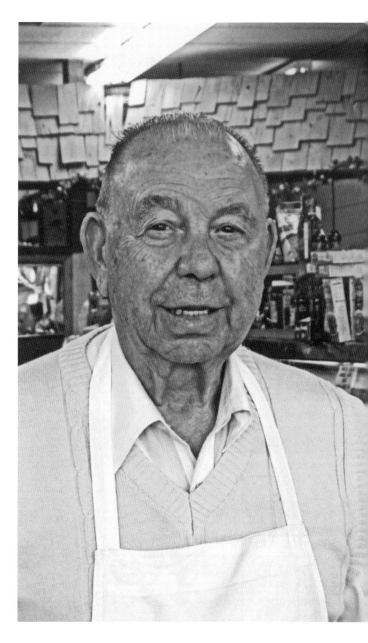

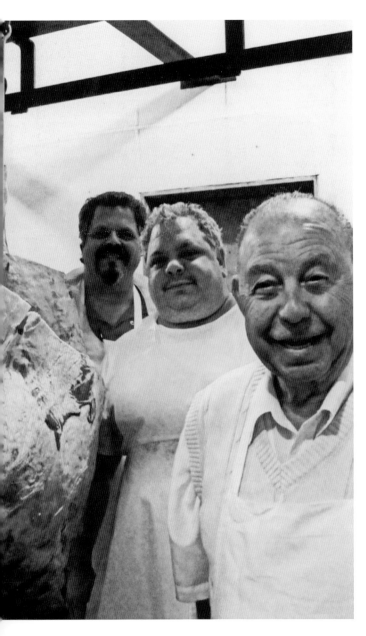

Mario's Meats

Mario's Meats will soon become another Eastpointe family business that is passed from one generation to another. Cercone says he's handing over the store's operation to his three sons and his son-in-law, but he still comes in daily. Because of his age, however, he comes in a little later: 6:00 a.m. instead of 5:00 a.m. Pictured here with their father in the meat locker are Giacomo (left) and Carlo (center). (Courtesy of Mario Cercone.)

Gus Guerra

Gus Guerra is probably one of the first Detroit bar owners to sell something known as pizza. It was early in the 1940s when he had his Sicilian mother came up with a dough recipe that he could then cover with cheese, tomato sauce, and all the fixings. To make it different from the pizza sold at another Detroit location, he put it into a square pan. That was the birth of the Detroit signature pie: square, thick-crusted, topped first with cheese and then with sauce. Guerra and his wife, Anna, came to Eastpointe soon thereafter, opening a little corner bar called the Cloverleaf at Wilson and Gratiot Avenues, where it has remained ever since. (Courtesy of Marie Easterly.)

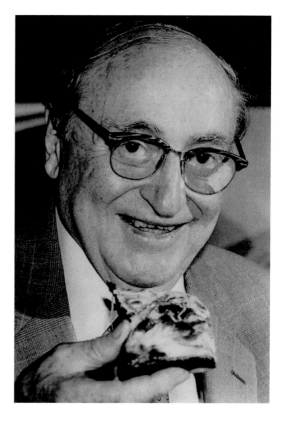

Gus Guerra's Cloverleaf Restaurant

Gus Guerra's Cloverleaf remains in its original location, which was chosen by Guerra and his wife many years ago. It was almost destroyed by a fire in 1993, but the family rebuilt it, complete with a great old-town atmosphere, including scores of old photographs and newspaper clippings framed on the walls. The restaurant's thick, aromatic, old-fashioned Detroit pizza continues to be made, and it compares favorably to other so-called Detroit pizzas that are polished versions of the old recipes. (Courtesy of Marie Easterly.)

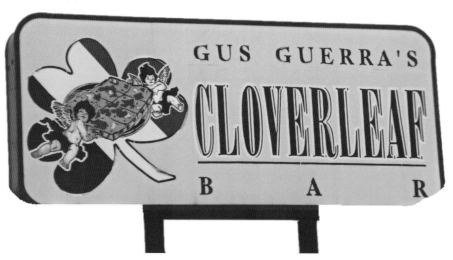

The Guerra Family
Gus Guerra's family took over the restaurant after Gus and his wife died. Today, son Jack and daughter Maria Guerra Easterly co-manage the successful, family-oriented business. Jack's son is also involved in the company, with a new Cloverleaf location recently opened in the northern part of the county. Many of the waitresses hired by Gus remain at Cloverleaf, becoming essentially part of the Guerra family. (Courtesy of Maria Easterly.)

George and Millie Curis

George and Millie Curis started a family business in Eastpointe that has lasted over 55 years. George Curis, the son of a Lebanese immigrant, started working at a young age at restaurants in the Dearborn area. His wife, Millie, contends that no one worked as hard as George, who would often spend the night at the location so the food would be ready for breakfast in the morning. When the time was right, he put in an offer to purchase a store. After buying the store, he made it an immediate success with all that he had learned from hard work. To George, quality food, top-notch customer service, and happy employees made the difference between success and failure. (Courtesy of Millie Curis.)

Eastpointe's Big Boy

Eastpointe's Big Boy was the location of the first Curis family business in town. George and Millie purchased a former drive-in restaurant and converted it to a sit-down establishment, complete with a sun porch. With three sons and two daughters, George was quick to get them all involved in the business, often making them work as hard as he had. The business is now owned by George's youngest son, Dan, who often has his three sons taking on various tasks. Many of the waitresses have been at this same location for over 25 years. The Big Boy franchise was a good fit for George, who ended up with seven of the chain's restaurants in the Metro Detroit area before his death. (Photograph by Mario Catalfio.)

Eastpointe's Subway (OPPOSITE PAGE)

Eastpointe's Subway marks the continuation of the Curis family tradition, now in its third generation. This is the second restaurant in the city for George's grandson, Michael, and his business partner, who redesigned this store according to the needs of the millennial generation. It offers customers an opportunity to sit down for a quick bite to eat, allows for easy in-and-out service, and has a 24-hour drive-through window to meet the needs of shift workers who reside in Eastpointe. It also upholds the major lesson taught by George: personalized customer service always comes first. (Photograph by Mario Catalfio.)

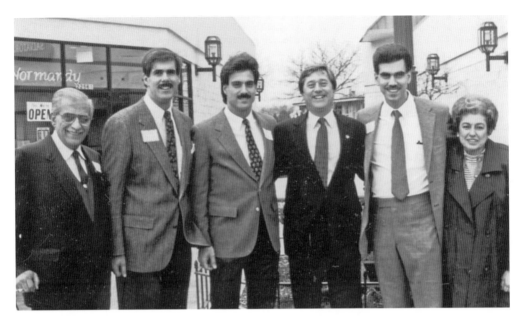

East Brooke Commons

East Brooke Commons was the next Curis project in the city of East Detroit. Over the years, the strip shopping center, located in the downtown section, had become extremely seedy. Many of the stores stood vacant and ready for demolition. George's son Mike came up with a plan for the city to demolish the properties, after which the Curis family would completely rebuild and maintain a major shopping plaza. Shown at the 1990 ribbon cutting for East Brooke Commons, are, from left to right, George Curis, sons George and Michael, Governor Jim Blanchard, son Dan, and George's wife, Millie. The shopping center was completed and occupied one year later. Today, the plaza is used for several different festivals and fairs and has recently become home to the Eastpointe Farmer's Market. (Courtesy of Michael Curis.)

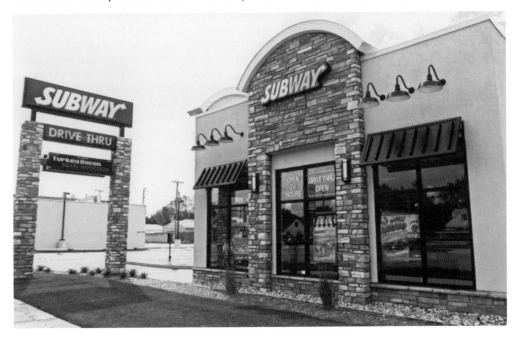

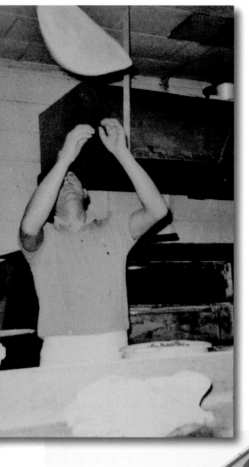

Orlando Palleschi

Palleschi will tell you that the first restaurant he opened in Detroit needed a gimmick. As a young Italian immigrant, he and his wife's family were doing well with traditional pasta dishes, but they wanted to make something "jazzy." Orlando had heard about pizza from *paisanos*, but needed to change it just a bit. The family moved to Eastpointe in the 1950s, and moved their restaurant, the Villa, to its present location on Gratiot Avenue near Eight Mile Road in 1955, just as pizza became the craze. He saw pictures of cooks throwing pizza into the air to thin out the dough, so he tried the flying pizza, which became his gimmick. (Courtesy of Anthony Palleschi.)

The Villa Today

Today, 55 years later, Palleschi's restaurant, the Villa, is still a family-run business. It attracts longtime customers and new clientele, too. Palleschi no longer throws pizzas in the air, but his original recipe is still in demand. His wife, Anna, no longer cooks the famous Italian dishes nor waits on tables, but their son Anthony, daughter Loretta, and son Joe use the same recipes, some with a modern twist, and share the restaurant responsibilities. The third-generation grandchildren will also work during school breaks. Orlando Palleschi still comes into the restaurant, checking it all out and making sure things are done right—and talking to his old customers. (Photograph by Mario Catalfio.)

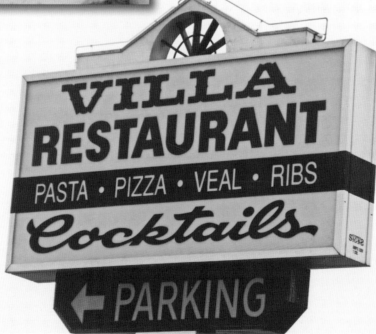

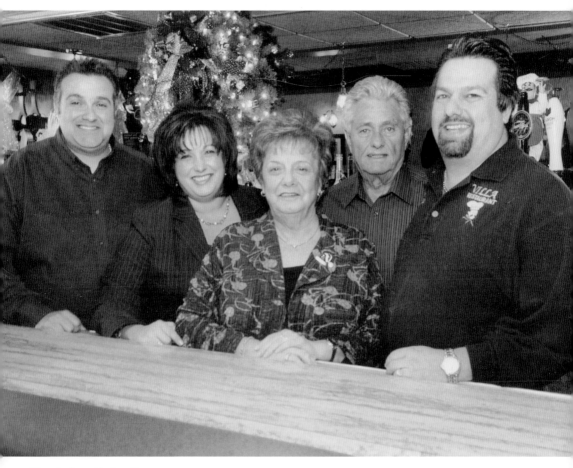

The Palleschi Family

Orlando Palleschi poses with his wife and children at the Villa Restaurant. Shown here are, from left to right, Joe, Loretta Cognetto, Anna, Orlando, and Tony. Anna and Orlando are the restaurant's founders and former co-owners. The children now co-own the Eastpointe establishment, which has been family-owned for over 55 years. The Palleschis are also very involved in the community. Anthony is the past president of the Eastpointe Chamber of Commerce, served for many years on the Downtown District Authority, and is a major sponsor of the annual Cruisin' Gratiot, even hosting a car show on his property during cruise week. He's on the East Detroit Scholarship Trust Fund and has provided spaghetti dinners as fundraisers in the past. He's also on the Macomb County Board of Health Advisory Committee. He helps out at all of the schools and churches, staying very involved. (Courtesy Loretta Cognetto.)

Fergan's Auto Parts

Another Eastpointe business that has enjoyed success over the past 50 years is Fergan's Auto Parts. The store's clientele, citizens of the Detroit Metroplex after all, are aware that, though cars will break down, they can be fixed with the right mechanic, and, more important, the right part. Over the years, Fergan's has earned a reputation of having some of the best clerks, all former mechanics, who can analyze a problem and have in stock the quality part that one needs. If it's unavailable, they know where to find it and can get it right away. (Photograph by Marco Catalfio.)

Thomas Fergan

Thomas Fergan is the semi-retired owner of Fergan's. According to his clerks, the reason for his success over a long period of time and despite many competitors is his high regard for customer service. He hires only clerks who have automobile mechanic experience, who know what they're talking about, and who know car parts. All of that comes to naught, however, if that same person does not have the personality to provide the expected service for the customer. It would seem that, in Eastpointe, the businesses that have survived are those that provide a quality product and a high level of customer service. (Courtesy of Thomas Fergan.)

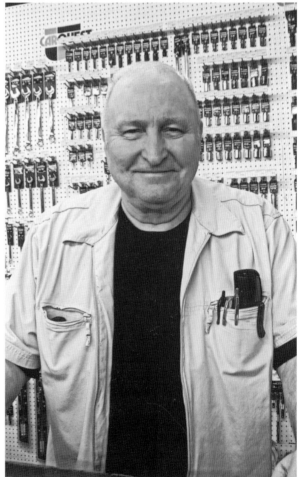

CHAPTER FIVE

Public Service

*The care of human life and happiness and not their destruction
is the first and only legitimate object of good government.*

—Thomas Jefferson

It was almost 100 years ago when the business leaders of southern Erin Township realized that for the area to prosper and develop, it would need to establish its own government. Initially, a charter commission was formed, which led to the creation of a village, approved by the voters and the state legislature in 1924. Almost immediately it became evident that, because of population growth, a change in government would be necessary, to that of a city government with a manager-mayor-council system. Within five years, that charter was approved by voters, and the City of East Detroit was born in 1929. Since that time, the name of the city has been changed to the City of Eastpointe, and the charter has been amended several times. The following pages will reveal some of the interesting political legends who have inhabited the area since the village was established. Noteworthy are the families who have been involved.

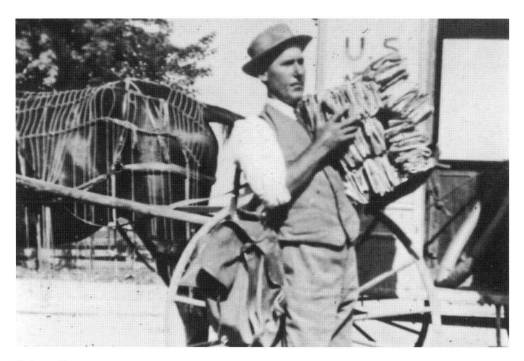

Robert Kern

Being the first postman to deliver mail to individual homes was one of Robert Kern's early jobs. While there were post offices in both Roseville and Halfway, there had been no delivery service until Kern talked the Roseville postmaster into allowing him to deliver to the individual farms. The idea was very well received. Initially, he delivered to the Halfway area only from the Roseville Post Office; later, he was allowed to deliver the Halfway mail, working out of the post office in the Halfway Hotel. (Courtesy of the East Detroit Historical Society.)

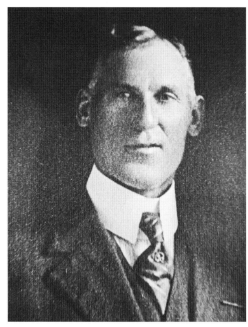

Mayor Robert Kern

Kern was elected the first mayor of East Detroit, serving a two-year term from 1929 to 1931. He was enormously popular at the time, part of a large family that had come to the area about 1835. At the time of his election, he was an electrician, a skill that he learned while working on the interurban, an electric streetcar that ran between most of the urban cities in southeast Michigan until 1916 and the advent of the automobile. (Courtesy of the City of Eastpointe.)

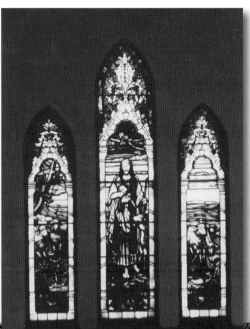

The Kern Family Windows

Initially, the Immanuel Methodist Church was located in a log cabin, located at Toepfer Road and Gratiot Avenue, and later moved to what is now the location of the police/courts building. When the new city of East Detroit was looking for a location for its municipal center, the church offered to sell its property. The church moved to just north of Ten Mile Road and Gratiot Avenue. A few years later, the State of Michigan elected to widen Gratiot, forcing another move to its current location. Knowing that the church relocation would be the last move, the Kern family sponsored these large stained-glass windows, located in the western end of the narthex. (Photograph by Marco Catalfio.)

The Kern Farmhouse

The Kern family home still stands at the farm's Ten Mile Road location. Though no longer part of the family, the home has essentially been kept intact, and still has a milk house in the back. Several members of the Kern family continue to reside in Eastpointe, and they are all active within the community, in the schools, and with Immanuel Methodist Church. In fact, it was the Kern family who sponsored the stained-glass windows on the west wall of the church nave. (Photograph by Marco Catalfio.)

George DeClaire

George DeClaire was one of four commissioners elected to the Village of Halfway in 1925. He was responsible for all health-related issues. As the population grew, a major problem concerned the wells and septic systems maintained at individual farms. People continued to die of waterborne diseases from contaminated well water. The area also regularly flooded; early spring runoffs made transportation impossible. DeClaire, seen here with his wife, Mathilda, worked diligently with engineers to set up plans to bring clean running water to every home and to install sewer and drainage systems. Those plans were implemented as the village grew. Many of the agreements set up with neighboring Lake Township (now St. Clair Shores) are still in place today. At the time, most villagers did not have a car and depended on Gratiot Avenue buses to get them to their jobs in downtown Detroit. DeClaire made sure that sidewalks were set in place along the main cross streets and Gratiot Avenue, offering residents safe and easy access to the buses in areas that were sometimes nothing but deep mud and, in some cases, quicksand. (Courtesy of the East Detroit Historical Society.)

Suzanne DeClaire Pixley

Suzanne Pixley is George DeClaire's granddaughter. When she ran for election as a councilwoman, she had no idea that her grandfather had served as a commissioner for the Village of Halfway. Her father had built a home for his family on his father's original farm property, so she grew up next door to her grandfather and knew him quite well before his death at the age of 72. His values about quality of life and helping others are what drove her to a nursing career and later a run for council. Historical research that Pixley conducted while president of the East Detroit Historical Society shed some light on her grandfather's life as a farmer, politician, and good neighbor. He moved to Chicago because of work following his time on the village commission, but returned to East Detroit after retirement. Coincidentally, Pixley returned to Eastpointe to care for her aging mother and now lives in the house built by her father in 1941 on the original piece of farm property her grandfather purchased in 1910. (Photograph by Sara Kandel.)

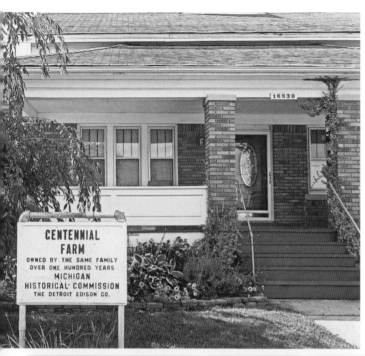

The Henry Hauss Centennial Farm

The Hauss family is another longtime Eastpointe family. Henry operated a small, six-acre farm and was a grocery store operator. One of four members of the Halfway Village commission, Henry Hauss was named chief of the fire department in 1928 and was later appointed police commissioner. He was one of the first members of the City of East Detroit City Council, serving from 1929 to 1931. Hauss was involved with businesses throughout the city and with St. Peter's Lutheran Church. (Photograph by Marco Catalfio.)

Hauss Descendants

The original family property, located just east of Gratiot Avenue on Hauss Avenue, continues to be inhabited by members of the Hauss family. Like their predecessors, they are very involved with St. Peter's Lutheran Church and School. Pictured here are members of the fifth, sixth, and seventh generations of the Hauss family. From left to right are Rudolph Jr. (holding Sara), Rudolph III, Carl, and Eva Hauss. (Courtesy of Rudy Hauss.)

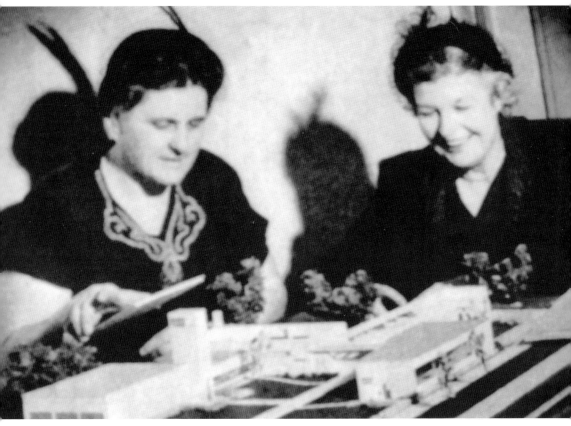

Betty Hayes

Betty Hayes (left) was the first female elected to public office for either the Village of Halfway or the City of East Detroit. An outspoken foe of the local amusement park known as Eastwood Park, she promised to work toward its expulsion from the community. She was elected at the same time as Mayor Harry McMillan. One year later, McMillan quit his post after Councilmen J. Ponder and Walter Sullivan resigned, leaving the reins of government in the hands of Hayes and newly elected Charles Yost, who also ran for office as an opponent of Eastwood Park. On the advice of the county prosecutor and the attorney general, the two remaining members of the city council met and appointed as the third member George Stone, who had been a runner-up in the election. With a quorum of three, they appointed a new mayor, Mildred Stark. She had been the leader of the forces aligned against Eastwood Park. Finally, the council members appointed a fifth member, Mr. Walther, a plumber, to restore the council to full status.

In the ensuing four years, this council, led by two women, accomplished many of their goals. They denied the amusement park's operating license and, though the case was fought all the way to a federal appeals court, the amusement park eventually moved out. City parks were improved, playground equipment added, and a new city hall was planned, approved by voters, and built. Hayes and Stark made for a dynamic duo. The local newspaper stated that so much had happened in one year with one mother, that what the future had in store for the populace was uncertain. For better or worse, the hands that rocked the cradle were now rocking East Detroit. (Courtesy of the East Detroit Historical Society.)

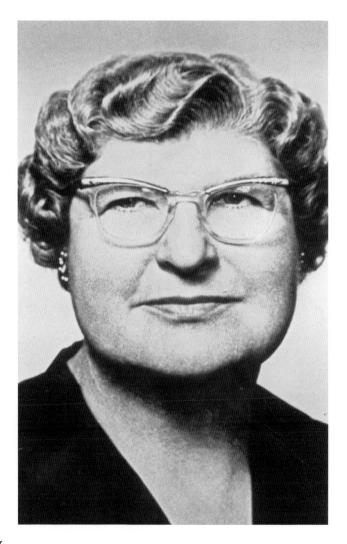

Mildred Stark

Mother of three, leader of the Mother's Club at her son's school, and leader of a group of citizens who wanted the local amusement park closed, Stark was appointed mayor of East Detroit in 1948. Stark, along with Betty Hayes and Charlie Yost, accomplished many goals that residents had been requesting for years. A curfew for those under the age of 17 was one of the first actions taken, followed by the addition of playground equipment. Plans were drawn up for a city complex to include police, fire, library, court, and city offices, and a push was made to establish more drains and sewers to eliminate basement flooding. Though the previous council had approved an operating license for the amusement park, Stark and her council were immediately able to deny a liquor license and a year later denied the operating license. Despite lacking public office experience, Stark found herself speaking with the governor, requesting his assistance with sewerage being dumped into Lake St. Clair. She dealt with the Department of Defense to change Warren's sewer lines so they would not run through East Detroit, and testified in courts all the way up to the federal level about Eastwood Park. Stark was easily elected to retain her position. In fact, East Detroit had the highest city voter turnout ever, particularly after a major push for voter registration was put in place. At the end of her full term, she served on the county board of commissioners and then returned to her life as a wife and mother. She ran for and was elected many years later for one term as a councilwoman and then retired for good. (Courtesy of the City of Eastpointe.)

Edward Bonior

Elected East Detroit mayor in 1963, Bonior served in that role until 1967. He ran for reelection, but was defeated by Walter Bezz. Of Ukrainian descent, Bonior had grown up in Hamtramck, moving to East Detroit during the 1950s. A young widower, he raised his three children by himself, assisted by a sister. Bonior loved the outdoors and wanted more people to enjoy it, running for office in an attempt to get a swimming pool for the children of East Detroit. He could not understand how a poor city like Hamtramck could have two pools, yet East Detroit had none. He accomplished a great deal while in office, including park improvements, creation of a nature trail and the pool, water system improvements, and the establishment of a water reservoir to help reduce the costs of residents' water bills. His children attended St. Veronica Catholic School and his sons later went to Notre Dame High. He had many proud moments in his life, including being chosen as a delegate to the Democratic National Convention and watching his son sworn in as a US congressman. Edward Bonior finished out his career working for Macomb County. (Courtesy of the City of Eastpointe.)

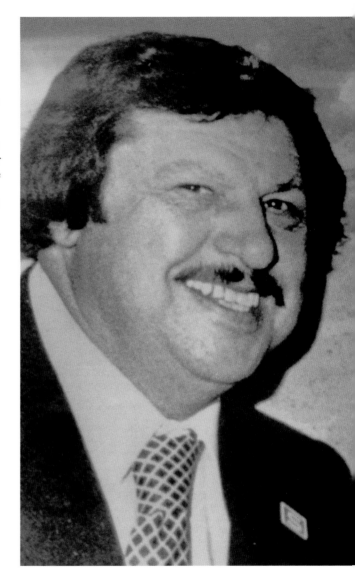

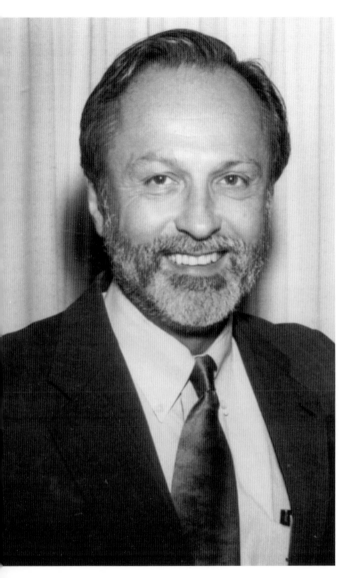

David Bonior

The son of former East Detroit mayor Edward Bonior, David Bonior graduated in 1962 from Notre Dame High School in Harper Woods, Michigan, where he excelled in sports. He received a BA from the University of Iowa, where he also played football, and earned an MA from Chapman College in Orange, California, in 1972. Bonior served in the US Air Force from 1968 to 1972, but did not see combat. He was elected to the US House of Representatives in 1976, serving there until 2002. During his tenure, he was the face of opposition to the North American Free Trade Agreement (NAFTA) and was known for his tenacity in opposing Speaker of the House Newt Gingrich. Bonior ran for governor of Michigan, but lost in the primary. Following his retirement from Congress, Bonior became a professor of labor studies at Wayne State University. Like his father, he claims that several of the important things he did in Congress related to the environment and labor. Bonior proudly points to many of the bike paths and trails that originated with his legislation. He lives in Washington, DC, with his wife, near his children and grandchildren. (Courtesy of Leo LaLonde.)

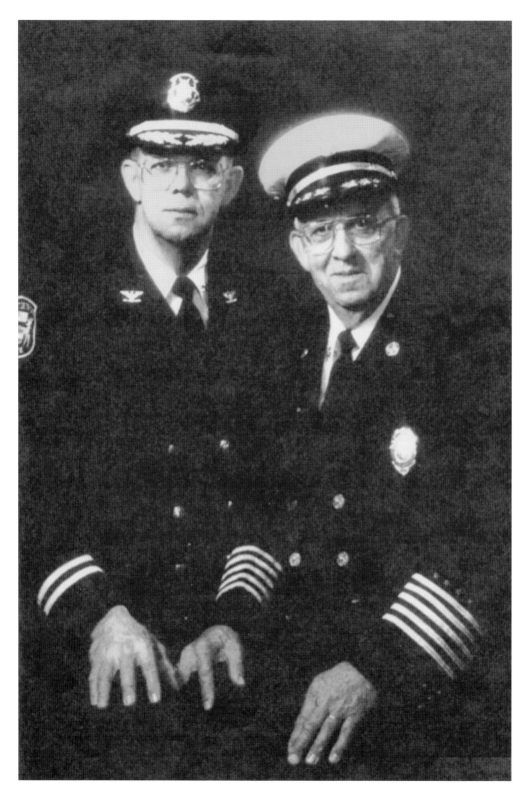

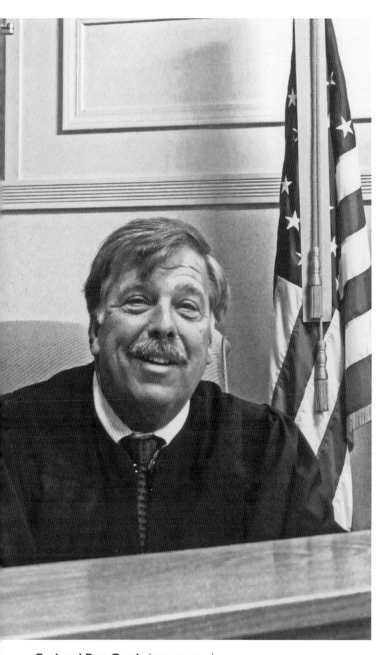

Carl Gerds III
A graduate of the University of Michigan Law School, Carl Gerds currently serves Eastpointe residents as 38th District Court judge. Like his father, Carl has been involved with community affairs. While running a busy law practice, he campaigned and won election to a city council position. He also served on the zoning board of appeals and on the Downtown District Authority for many years. Since becoming a judge, he has streamlined the court, making it more efficient and productive. He continues to reside in Eastpointe, as do all three of his daughters, one of whom works in the senior citizen office. (Courtesy of Judge Carl Gerds III.)

Carl and Ron Gerds (OPPOSITE PAGE)
The Gerds make up the only all-brother team to simultaneously hold department head titles in the City of Eastpointe. Police chief Ron Gerds (left), like his brother, fire chief Carl Gerds II, came up through the ranks, becoming an officer and then chief. Both were extremely well liked by officers working under them, as well as by the city management, the mayor, and the city council. Both of these chiefs were heavily involved in community, church, and school events. Carl is now deceased, and Ron continues to be seen regularly at community events. (Courtesy of Gordon Gerds.)

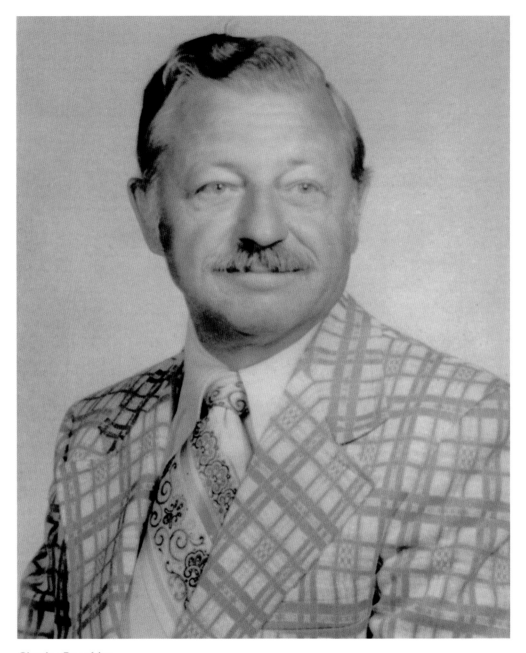

Charles Beaubien

Charles H. Beaubien had served as acting clerk, assessor, and assistant manager before being appointed acting city manager and, finally, city manager in 1953. He continued in that position until 1975, when he retired with 34 years of service. He was essentially a lifelong East Detroit resident, though he did move north to his cottage following his retirement. Beaubien saw the city through financial challenges, rapid population growth, and increasing service needs. He set up ambitious infrastructure improvements and was able to provide sidewalks and pave every street in Eastpointe before he retired. He worked side by side with city treasurer and director of finance Esley Rausch for over 30 years. (Courtesy of the East Detroit Historical Society.)

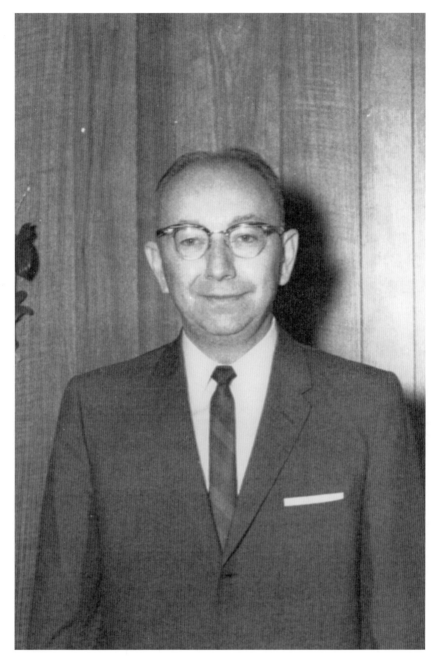

Esley Rausch

Employed as deputy treasurer in 1934, Rausch was appointed city treasurer and director of finance in 1937. He continued in that position until his retirement in 1975. During his 41 years of employment, Rausch faced many financial hurdles, but he developed creative solutions. The infant city of East Detroit came into existence with a bonded indebtedness of over $2.5 million. The Depression and high unemployment followed, which meant that people were unable to pay their taxes or special assessments. Through careful planning and creative bond refinancing, the city was able to refinance and reissue bonds, completely paying off all city debt by October 1959. (Courtesy of Clair Kansier.)

Harvey Curley

Harvey Curley was elected East Detroit mayor in 1987, serving in that position for the next 12 years. Born and raised on a small farm in Southern Illinois, he first came to the Detroit area following his service with the US Air Force in Morocco. He settled in East Detroit and has been in the area ever since. He was active with the Forest Park PTO and was elected to the East Detroit School Board for several years before deciding to run for mayor. He defeated incumbent Joe Portelli in his first race, and ran unopposed for his second and third terms. (Courtesy of Harvey Curley.)

Curley and the Cardinal

Harvey Curley (left) is seen here welcoming Cardinal Adam Maida, the area's highest-ranking Catholic, to East Detroit. The occasion was the dedication of the parish hall at St. Basil the Great Catholic Church, on the east side of the city. (Courtesy of Harvey Curley.)

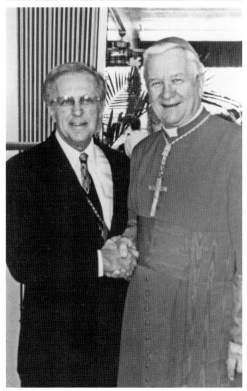

Harvey Curley and Cruisin' Gratiot
Cruisin' Gratiot is now an Eastpointe tradition, featuring a full week of car shows and ending with a two-mile parade of classic cars in dedicated lanes on the main street of town. It began as a chamber of commerce one-day event, but has grown to be Eastpointe's biggest event. Harvey Curley has been one of its biggest supporters, remaining a member of the board of directors and currently serving as treasurer. He is seen here with former economic development director Steve Horstman (left) as they work to get the cars lined up for the VIP parade. (Courtesy of Harvey Curley.)

Harvey Curley, Goodfellow Salesman
Harvey Curley is seen here standing on his usual corner on the first Saturday of December, selling *Goodfellow* newspapers. He has done this every year for over 25 years, to be sure that no kid in Eastpointe goes without a toy at Christmas. He will tell you that, as a kid, he often went without a toy, and does not want that to happen to an Eastpointe child. During the newspaper fundraiser, Curley usually works at the same corner, all day for two days running, despite freezing temperatures and no matter how much snow falls. People head to his corner, where he collects more cash than any other salesperson. For several years in a row, he has organized a toy party. Pizza is donated by local merchants, and attendees pay a $5 admission or bring a toy. Traditionally, the toys have been distributed by the Eastpointe Fire Department. (Courtesy of Harvey Curley.)

Mike Lauretti

Nike Lauretti is seen here on his first day of police service 32 years ago. Recently retired, he recalls that day as being one of the most exciting of his career. Lauretti and the car are next to the entrance to East Detroit High School, where he had graduated a few years before. From this beginning, Lauretti moved up the ranks not just of the East Detroit/Eastpointe police department but of other police organizations as well. He attended the FBI Academy for Police Chiefs at Quantico, and not only became president of the Southeastern Michigan Chiefs of Police, but also served on the board of the Michigan Chiefs of Police Association, becoming president in 2010. He was extremely involved with the community, serving as the president of the Networking Forum for over 10 years. He also worked to establish a group called PACE (Police and Community for Equality), which continues to bring people together to work on diversity issues. During his last year at the department, Lauretti was appointed to the Governor's Board on Public Safety. (Courtesy of Mike Lauretti.)

Officer Lauretti

Accompanying Mike Lauretti as he is sworn in on his first day of duty is his father, Michael, who appears very pleased with his son and his choice of career. Mike's father died a few years later, making this father-son moment even more precious. Knowing what this day meant to both he and his father, Chief Lauretti has continued to make all swearings-in and promotion ceremonies family events in Eastpointe City Hall. Parents, spouses, and children are invited, and often, it is the father of the new officer who pins on the badge. (Courtesy of Mike Lauretti.)

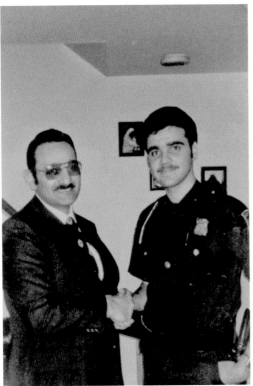

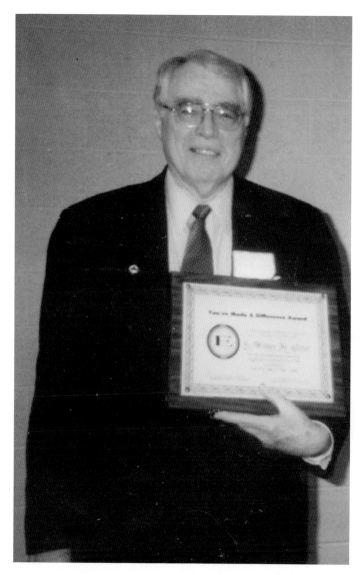

Wes McAllister

McAllister came from Casper, Wyoming, to accept the position of Eastpointe city manager in September 1988. During the next 12 years, he incorporated many tools and techniques that boosted economic development in the city and enhanced residential services. A Downtown District Authority was established for the maintenance and development of the city's central core, and McAllister worked with private developers to establish East Brooke Commons. Gateways were built to enhance the entrances and main intersections of the city, a new court building was erected, and a large community center was purchased. Other accomplishments included a new department of public works complex, new street lighting for Gratiot Avenue's median from Eight Mile to Ten Mile Roads, and—what every resident was requesting—advanced life support training for the firefighters. McAllister was one of the few city managers who actually lived in the city, and this afforded him nonstop observation of what was happening. He was heavily involved in community events and projects. Yet, in 1999, two council members decided that he was not a team player and, acquiring the support of a newly elected city councilman, voted to terminate McAllister's contract. (Courtesy of Sue Young.)

James Friedman

James Friedman (center) was the first local minister to volunteer as a chaplain with Eastpointe's police department, initially riding with a police officer on busy nights. He then went through the Reserve Police Officers Academy and became a reserve officer. Friedman assisted first responders when they found themselves in difficult situations—the death of a baby, a suicide, or consolation of a family whose teenager had been imprisoned. Friedman worked closely with all of the officers and provided counseling to youth who found themselves in trouble. He is seen here receiving a Chaplain Appreciation Award from police chief Mike Lauretti (right) and deputy police chief John Calabreese (left). Three years ago, Friedman began working with the Macomb Community College Police Academy, providing one-day seminars for potential police chaplains. Recently, the service has expanded to a 10-week program. He continues to be involved with the community, where he is chair of the PACE group and still maintains his role as pastor of a large church in Eastpointe. (Courtesy of Mike Lauretti.)

CHAPTER SIX

Military

*These endured all and gave all that justice among nations might prevail
and that mankind might enjoy freedom and inherit peace.*

—Author unknown

The Eastpointe area has always been a supporter of the armed forces. Large numbers of residents have answered the call to service, including men who could not serve on active duty and spouses left behind, working in the factories that were part of the arsenal of democracy. Although the records related to participation in the Civil War have been lost, a group burial plot from that era is found in St. Peter's Cemetery. Old newspaper articles recall the World War I draft, send-off parties, and homecoming parades. Veterans groups of all types were formed at that time, with two VFW posts and an American Legion post remaining in the city. World War II had a significant effect on Eastpointe. It is estimated that 40 percent of the population went off to war. Some fought on the beaches of Normandy, while others served in North Africa, the Aleutian Islands, Guadalcanal, and other parts of the South Pacific. Most were welcomed home with huge parades. Memorials to those who did not return were built. Also of consequence were the Korean and Vietnam conflicts, in which large numbers of local residents served. Today, the city recognizes active-duty and retired troops and their families. Memorials have recently been reconstructed to honor the fallen. In this chapter, a few representatives have been chosen to illustrate the city's involvement. A recent museum, the Michigan Technical Military Museum, has been opened to commemorate the area's involvement with the technical aspects of the military.

World War II Plaque
This plaque, located on the Veteran's Memorial in Eastpointe's City Hall Plaza, salutes the 38 East Detroit High graduates who gave their lives during World War II. Among them are the son of East Detroit's mayor at the time and the son of East Detroit High's principal. Returning veterans led local fundraisers to establish Memorial Field and Memorial Stadium as lasting tributes to those who did not return. (Photograph by Marco Catalfio.)

Perpetual Memorial (OPPOSITE PAGE)
In 1959, this small memorial was placed by the City of East Detroit on the grounds of City Hall in honor and memory of all those who served their country in times of peace and war. This marker stands in remembrance of those who served in the Civil War and World Wars I and II, as it was difficult, in the era before computers, to find their names and locations. Over time, this small memorial became barely visible behind overgrown bushes. When the new city hall was built, the marker was moved to a prominent location in the middle of City Hall Plaza. (Photograph by the author.)

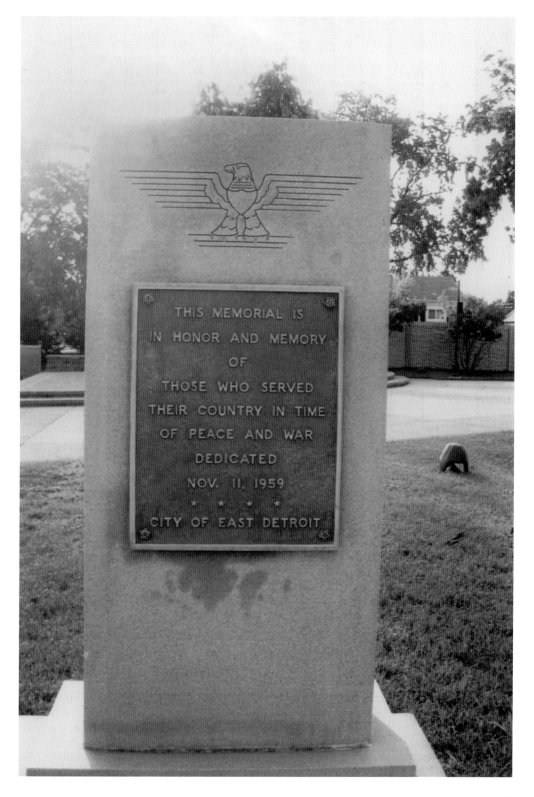

THIS MEMORIAL IS
IN HONOR AND MEMORY
OF
THOSE WHO SERVED
THEIR COUNTRY IN TIME
OF PEACE AND WAR
DEDICATED
NOV. 11, 1959
★ ★ ★ ★
CITY OF EAST DETROIT

Iwo Jima Resolution

In 1987, the Eastpointe City Council chose to recognize the 42nd anniversary of the historic battle of Iwo Jima and Richard Nummer as the sole surviving Marine of that battle from East Detroit. The Eastpointe Memorial Library was chosen to display this photograph of the Iwo Jima Memorial that stands in Washington, DC. The framed Certificate of Recognition, displayed below, describes Nummer as a decorated corporal in the US Marines, 28th Regiment, 5th Division. It describes Iwo Jima as one of the bloodiest battles in military history, with 5,931 killed and 17,272 wounded. Nummer's role is described as follows: "Against medical advice, Richard Nummer landed on the island of Iwo Jima on Feb. 19, 1945. Four days later, the famous flag raising occurred on Mt. Suribachi. Richard Nummer was one of twenty marines to first sleep on top of the summit and defend the flag. Richard Nummer remained on the island for thirty six days and celebrated his nineteenth birthday there on Feb. 27, 1945." (Photograph by the author.)

Richard Nummer (OPPOSITE PAGE)

Nummer volunteered right after Pearl Harbor, but was initially sent home when the Marines found out he was only 16. When he turned 17, he again joined the Marines, trained in California, and quickly joined troops in the war in the South Pacific. At Iwo Jima, he was in the first group of Marines that stormed the heavily fortified island, and was there as the American flag was lifted on Mount Suribachi. After Japan's surrender, Nummer was part of the occupation forces at Nagasaki. He is pictured here at the age of 88, proudly wearing his original Marine uniform. (Photograph by the author.)

Francis Andary

Andary, an example of those who answered the call to serve in Korea, was one of 13 children being raised by his widowed mother. When he was 17, he made his mother sign his underage permission slip, claiming that he would get into trouble if she did not. His Lebanese mother could neither read nor write English, so he showed her where she needed to draw an "x." Soon, he and one of his brothers joined the ranks of the US Army. Both were sent to Korea after basic training, but neither knew the other was in the same country at the same time. When they returned home, they discovered that they had often been within miles of each other. Only upon returning home did Francis find out that his brother had been seriously injured and awarded the Purple Heart. (Courtesy of Marco Catalfio.)

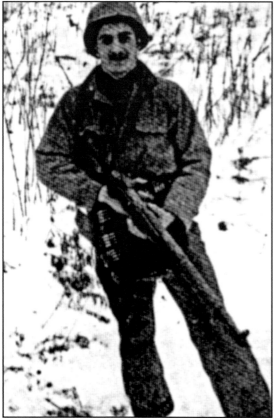

Sergeant Andary

Sergeant Andary is shown here in the mountainous region of northern Korea. Today, he recalls his time spent at war as very difficult, involving extremely cold temperatures, fierce fighting, and uncertainty about his location and immediate surroundings because of the mountainous terrain. Andary knows that he was in North Korea at times, surrounded by the enemy, but he is not quite sure how he got out of conflicts essentially unharmed. He chalks it up to his determination to get home to his mother, who he promised he would return to help with the family. (Courtesy of Francis Andary.)

Andary Family

Today, the Andary family possesses the same determination that Francis displayed during the war, opening one of Eastpointe's most popular eating establishments. For the past 17 years, the family has provided locals with traditional American home-cooked foods and outstanding customer service. The restaurant continues to attract people from all over the area. Many of the items on the menu are traditional Lebanese recipes from Francis's mother. Now in his 80s, Francis continues to work two days a week while his sons and grandsons and their spouses manage the kitchen and the wait staff. Francis's wife continues to bake the special cakes and desserts. Family members pictured here are, from left to right, Joseph Gilbert, Kelly Andary, Angela Gilbert, and Pete Andary. (Photograph by Marco Catalfio.)

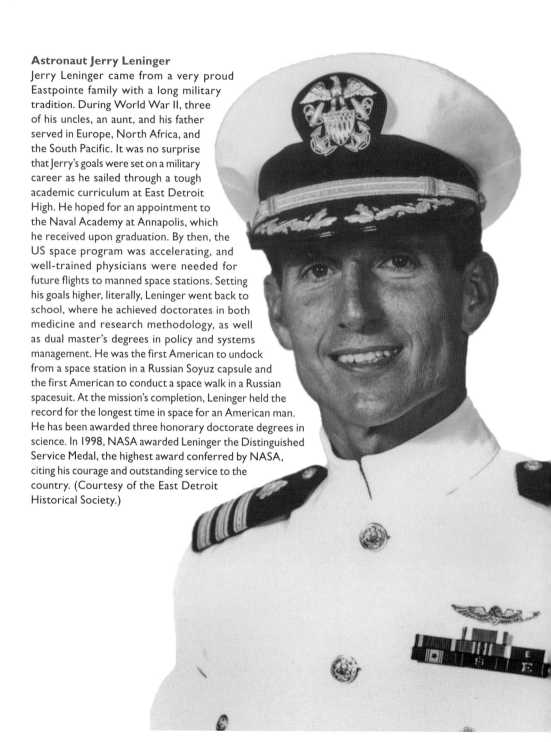

Astronaut Jerry Leninger
Jerry Leninger came from a very proud Eastpointe family with a long military tradition. During World War II, three of his uncles, an aunt, and his father served in Europe, North Africa, and the South Pacific. It was no surprise that Jerry's goals were set on a military career as he sailed through a tough academic curriculum at East Detroit High. He hoped for an appointment to the Naval Academy at Annapolis, which he received upon graduation. By then, the US space program was accelerating, and well-trained physicians were needed for future flights to manned space stations. Setting his goals higher, literally, Leninger went back to school, where he achieved doctorates in both medicine and research methodology, as well as dual master's degrees in policy and systems management. He was the first American to undock from a space station in a Russian Soyuz capsule and the first American to conduct a space walk in a Russian spacesuit. At the mission's completion, Leninger held the record for the longest time in space for an American man. He has been awarded three honorary doctorate degrees in science. In 1998, NASA awarded Leninger the Distinguished Service Medal, the highest award conferred by NASA, citing his courage and outstanding service to the country. (Courtesy of the East Detroit Historical Society.)

Leninger Display
This Leninger display, currently located in the Michigan Military and Technical Museum, is a testimony to the town's respect for one of its hometown heroes. Multiple showcases and cabinets were purchased through the efforts of Eastpointe's Kiwanis, Lions, and Rotary clubs to display Leninger's accomplishments. Shown here is one of Leninger's jackets. (Photograph by Marco Catalfio.)

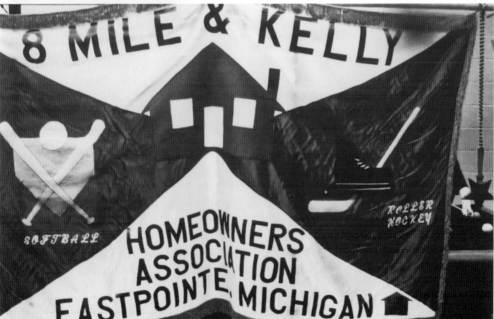

8K Banner
This banner was designed and made in one night by local businessman Tom McCauley and his mother. Just before Leninger's departure for Russia and outer space, it became known that he could bring along something from Eastpointe for the six-month mission. Photographs from the space station show this bright green banner floating—a reminder of the family and friends supporting Leninger and awaiting his safe return. Other Eastpointe items that went with Leninger on one of his two trips to space include a library card, an Eastpointe city flag, and a T-shirt from the Eastpointe Swimming Pool, where Leninger had worked as a teenager. (Courtesy of Sue Young.)

Greg Bowman

Greg Bowman (second from right) is one of the proud members of Vietnam Vets, Chapter 154, a group that has worked extremely hard to recognize the service of the war's veterans. While a veteran's memorial had previously been built to salute the Eastpointe men who lost their lives in Vietnam, it was crumbling and no longer a fitting memorial. Working with the architect who designed Eastpointe's City Hall, Bowman and others from the VFW, the Auxillaries, the Lions, and the Eagles came up with a design that would memorialize fallen Eastpointe servicemen from all wars and conflicts. Within three months, the design was completed, the funds had been raised, and the Vietnam Vets, led by Greg Bowman, had taken on the task of building the memorial themselves. (Courtesy of Greg Bowman.)

The Vietnam Veterans Memorial

Building the memorial was no easy task for many of those who had sustained disabling injuries during the war. Their determination was evident as they picked out the black granite blocks, built the foundation, set the lighting, established the memorial paver block patterns, and finally applied the black granite and plaques honoring those who lost their lives. They called it a labor of love. When it was done, an unveiling was held during a Veteran's Memorial Day ceremony at City Hall with all of the well-deserved military honors. (Courtesy of Greg Bowman.)

Eastpointe City Hall Veterans Memorial

The Veterans Memorial at Eastpointe City Hall is three large pieces of granite with plaques honoring those who lost their lives during World War II, Korea, and Vietnam. The memorial was funded by contributions from local service and fraternal organizations and from money raised through the purchase of memorial pavers, bought by residents to remember friends and relatives who had served in the military. (Photograph by Marco Catalfio.)

Vietnam Plaque

This plaque was moved from an older memorial, built right after the Vietnam conflict, to its current location on this piece of black granite. During the conflict, 16 East Detroit residents lost their lives. In addition, a large number of residents were drafted for service right out of high school. (Photograph by Marco Catalfio.)

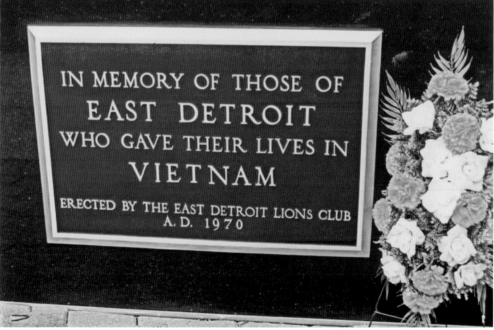

IN MEMORY OF THOSE OF
EAST DETROIT
WHO GAVE THEIR LIVES IN
VIETNAM
ERECTED BY THE EAST DETROIT LIONS CLUB
A. D. 1970

Sea Cadets

Young teens, male and female, join the Sea Cadets to learn not just nautical skills, but also leadership training and physical endurance. The Sea Cadet group pictured here has garnered a large number of accomplishments and awards, and two from the group received appointments to the Naval Academy and one to the Coast Guard Academy following high school graduation. This photograph depicts their service during a Veteran's Day ceremony, in which they were chosen to act as honor guards at the Vietnam Wall Display. (Courtesy of Jerry Van De Vyver.)

Sea Cadet Leaders

These leaders play a large role in the success of the Navy's Sea Cadet program. Seen here are three from the local Tom Cat Squadron, Jerry VanDeVyver and Mr. and Mrs. Tom Ferrill. These leaders accompany the Sea Cadets to parades, routine training at Selfridge Air National Guard Base, large group training at Fort Custer in Battle Creek, and state competitions at Central Michigan University. Sea Cadets and their leaders also spend time on the Great Lakes on an actual Navy training ship, where they expand their skills. (Photograph by the author.)

CHAPTER SEVEN

Sports

I don't believe you have to be better than everybody else.
I believe you have to be better than you ever thought you could be.

—Ken Venturi

Eastpointe has only one high school. Since it opened in 1930, sports and physical education have played a huge role in the life of its students and their families. This chapter outlines some of the amazing accomplishments achieved at the high school level and details the exploits of residents who played at the collegiate and professional levels. Many of the records for individual and team performance may never be broken, but they remain as challenges to future student athletes. A great deal of credit for preserving this information goes to previous players, coaches, athletic directors, and, most recently, the East Detroit High School Athletic Hall of Fame committee. Their endless research and gathering of data have been labors of love. Most of the images used in this chapter are courtesy of the hall of fame committee, and credit must be given to Chris Schneider, Larry Andrewes, and Gerry Kaminski.

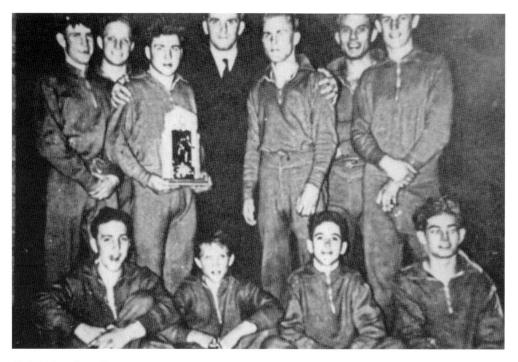

1940 Wrestling Team
The 1940 wrestling team won the first championship ever by an East Detroit High program. The team swept all seven of its dual matches and began a winning tradition that was to include state and invitational team championships in 1941 and 1942, before World War II interrupted.
(Courtesy of the East Detroit Historical Society.)

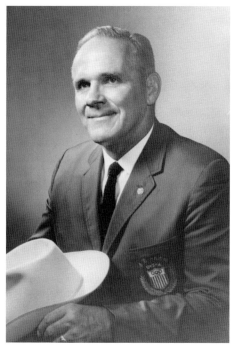

Dean Rockwell
Dean Rockwell (1938–1942) came to East Detroit High as a coach of football and track, but also started a wrestling program to fill the winter hours. Under his guidance, the Shamrocks quickly became the talk of the state, becoming state champions by 1940. They repeated that feat in 1941 and 1942, winning nine individual state championships. Rockwell resigned in May 1942 to serve in the US Navy during World War II. After 43 months in the service, he returned to Michigan, earning his MS at the University of Michigan and joining the faculty at Albion. He remained active in wrestling for over 45 years, coaching world championship and Olympic Greco-Roman teams. He made his mark as an ambassador for wrestling, and it all started in East Detroit before reaching out to the state, the country, and the world.

Harold Oehmke

Harold Oehmke was one of East Detroit High's earliest athletic stars. He won eight letters between 1937 and 1941: three in football, two as a heavyweight wrestler, and one each in the shot put, discus, and relays. On the mat, Oehmke placed second in the heavyweight division in the Michigan Interscholastic Meet in 1940, winning the division in 1941. He was All-College heavyweight champion at Michigan State. Impressive as a wrestler, he was better with the shot put, taking titles in 1939, 1940, and 1941, including a two-time state championship at the MHSAA Track and Field Finals. Topping things off, Oehmke in 1942 added a shot put title at the US Army/Air Force Cadet Mid-Western Championship. (Courtesy of East Detroit High Athletic Hall of Fame.)

Dick Lisabeth
A 1951 graduate of East Detroit High, Lisabeth earned nine varsity letters in football, basketball, and baseball. Moving on to Wayne State, he earned four letters in football and established himself as one of the premier players in WSU gridiron history. After a two-year career with the Detroit Raiders, he taught in the Detroit schools and continued as a football and basketball official for 25 years. (Courtesy of East Detroit High Athletic Hall of Fame.)

Meryl Toepfer (OPPOSITE PAGE)
Meryl Toepfer excelled on the football field and on the basketball court, winning four letters in football while playing quarterback and three letters in basketball while playing the guard position. Because he played from 1934 to 1938, there are not many records of his accomplishments while at EDHS, but older fans remember him as a talented, all-around athlete. His gridiron ability earned him notice from the University of Detroit, where he was given a full scholarship to play football for the Titans. Following graduation, he enlisted in the US Navy during World War II and received airplane flight training, which he really enjoyed. After the war, he was hired by Standard Oil and became the company aviation representative. He was assigned a company plane, and he called on airports in six Midwestern states. He currently lives in Florida with his wife, Alvira, a 1940 East Detroit graduate. (Courtesy of East Detroit High Athletic Hall of Fame.)

Louis Marcetti

Louis Marcetti is one of the athletes whose career brought him back to East Detroit High after his high school and college playing days. He was a five-letter man at EDHS between 1948 and 1951, earning three letters in football, playing both offensive and defensive tackle, and two letters in track, running the 440-yard dash. He left his mark on the football field, achieving first-team status on the All-EML squad, the All-Suburban squad, and the All-Metro team his senior season. He was named Macomb County Player of the Year and was named All-State by five different groups. Following his prep career, Marcetti attended Michigan State University, were he earned a varsity letter in football before his playing days ended with an injury. His connection with East Detroit continued, however, as Marcetti had a long career of service to the district, including many years of coaching and serving as assistant principal at East Detroit High. (Courtesy of East Detroit High Athletic Hall of Fame.)

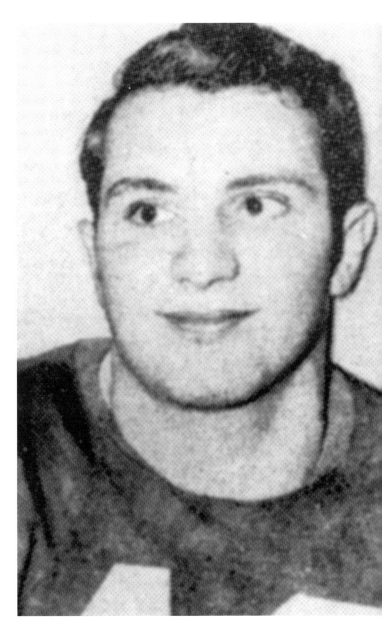

Ron Kramer
Ron Kramer set a record in high school, winning not only letters in three sports, but also All-State honors in those three sports: football, basketball, and track. While attending the University of Michigan, Kramer won nine varsity letters in all three sports and was named football All-American in 1955 and 1956. Following graduation in 1957, he joined the Green Bay Packers and played a leading role on the world championship teams coached by Vince Lombardi. He joined the Detroit Lions in 1964, and was named All-Pro twice and played in the Pro Bowl once. Kramer was inducted into the Michigan Sports Hall of Fame in 1971, the Green Bay Hall of Fame in 1974, and the National Football Foundation Hall of Fame in 1978. (Courtesy of the East Detroit Historical Society.)

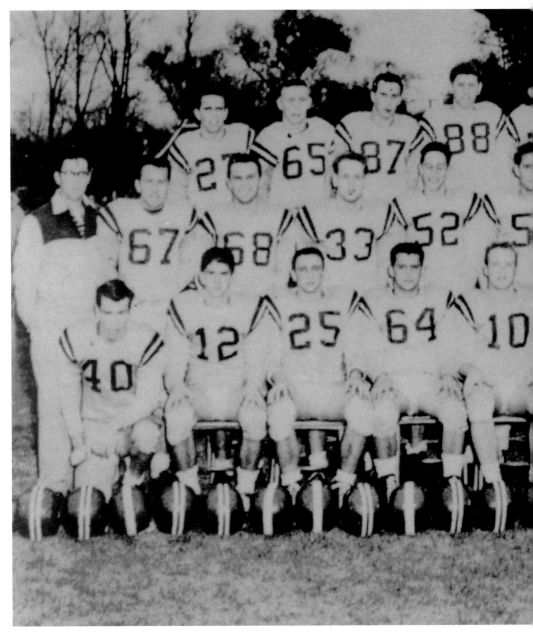

1956 Football Team

Coached by Al Asbury, and featuring a slew of returning lettermen, the 1956 football team took dead aim on the school's first EML football championship. When the dust settled, the Shams had rolled to a 9-0 record, an EML title, and a number-two ranking in the state polls. The team outscored its nine opponents 267-40, recorded four shutouts, and allowed only one opponent to score more than one touchdown. The Shams rushed for 2,059 yards that year and scored a total of 33 touchdowns. The defense allowed an average of less than five points a game. It was probably the greatest gridiron team in East Detroit history, and featured three future pro football players: Gary Ballman, Mickey Walker, and Neil Thomas. Al Asbury was named County Coach of the Year. The 1956 team is the standard by which all Shamrock

football teams have been and will be measured. Shown here are, from left to right, (first row) Wayne Deighton, Ed O'Hara, Toby Prantera, Tony Basone, Jim Balkwell, Mickey Walker, Ron Gauss, Arnold Gloacki, Dan Angel, Gene Clifton, and Ken McGuffie; (second row) coach Ron Gess, Jim Turner, Harry Benvenuti, Jim Klabius, Jim Pontieri, Richard Wisniewski, Ron Emerick, Gary Ballman, Alan Sulki, Frank Sands, coach Al Asury, and coach Larry Hartsig; (third row) Jim Webb, Keith Schreck, Eugene Picard, E. Zormeier, Chris McChesney, Neil Thomas, Ron Visbara, Eric Olsein, and Ken Warner. (Courtesy of East Detroit High Athletic Hall of Fame Committee.)

Gary Ballman

A 1958 East Detroit High graduate, Ballman earned three letters in football, basketball, and track, in each of three years. His accomplishments in track included establishing school records in the hurdles and placing in state finals. In basketball, he was named All-League, All-County, and Honorable Mention All-State. Football, however, was his preeminent sport. He was named All-State in his junior year, scoring 24 touchdowns and helping his team to an undefeated season. He accepted a football scholarship to Michigan State, where he played first string in his sophomore year and for the remaining three years. His coach at Michigan was Duffy Daugherty. Ballman played 12 seasons in the National Football League, five for Pittsburgh and six for Philadelphia, before finishing his career with the Giants and Vikings in 1973. During his career, he earned All-Pro honors and participated in Super Bowl VIII. (Michigan State University Archives and Historical Collections.)

Mickey Walker (OPPOSITE PAGE)

Mickey Walker played football for East Detroit High for three years. A mainstay at fullback and linebacker, he was captain for two years and was named All-County and All-State as he led his team to a perfect nine wins and no losses in his senior year. He was also outstanding in track and field, setting school records in the shot put in 1957 and placing third in the state meet. Walker accepted a football scholarship to Michigan State, where he started for three years, and was named All Big Ten as a senior. He was drafted by the New York Giants and played either center or guard. He was known for his aggressive style and was named captain of the special teams, a job he held for four years. (Courtesy of East Detroit High Athletic Hall of Fame Committee.)

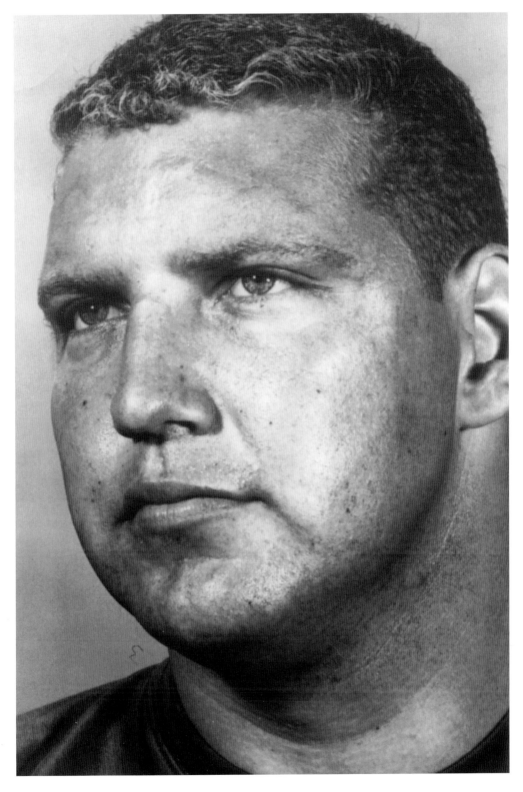

Toby Prantera

Toby Prantera is another East Detroit High athlete who earned three letters each in football, basketball, and track. He ran the 220- and 100-yard dashes as well as the half-mile relay, and was a high jumper as well. In basketball, Prantera was a guard, playing a big part in the Shamrocks' successful season his senior year. East Detroit were the EML champions in that 1956–1957 season, finishing with a perfect 8-0 league mark. Prantera was the third-leading scorer on the team his senior season, hitting 57 field goals and 51 free throws for a total of 165 points. In football, he also excelled, being named All-EML, All-County, All-Suburban, and All-State in his junior year. His senior season saw him named to the All-County team as the Shams rolled to a 9-0 record and won their first EML title. In those two seasons, Prantera scored eight touchdowns as a halfback and kicked nine extra points to account for 57 Shamrock points. He later attended Indiana University. (Courtesy of East Detroit High Athletic Hall of Fame Committee.)

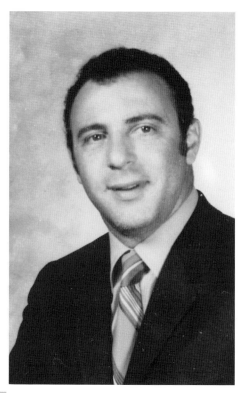

John DeGrandis

While attending East Detroit High, John DeGrandis had three outstanding years in cross-country and track, earning three varsity letters in each sport as he established new school records in the mile, two mile, and three mile. He was selected Most Valuable Player for each of his three years of cross-country competition. He was named to the All-League team in 1974 and 1975, and to the All-County and All-Region teams in 1975. DeGrandis qualified for state finals in his senior year and, as a result of his performance, was named to the All-State team. On the track team, he took part in the 440, 880, mile, two mile, long jump, and mile relay. He was All-League in 1975 and 1976 and All-County and All-Region in 1976. After graduation, he continued running cross-country and was named a National Junior College Academic All-American Honorable Mention in 1976, followed by first-team Academic All-American in 1977, with a 4.0 grade point average.

Matt Hernandez

Matt Hernandez is another of the Shamrock greats who was able to make the jump from standout prep star to college ball, and then on to the pros, enjoying a four-year NFL career. While at East Detroit, Hernandez earned four letters, two in heavyweight wrestling and two in football, playing defensive end and offensive tackle. As a wrestler, Hernandez was All-Conference. But the gridiron is where he made a name for himself. He was All-Conference and second-team All-State his junior year. In his senior year, he was a Shamrock captain and led the squad in sacks and tackles. He was first-team All-Conference, All-County, and All-State while earning a scholarship at Purdue for his play. At Purdue, he was a four-year letter-winner at defensive tackle and a three-year starter. In his sophomore season, he was Honorable Mention All Big Ten. By his senior year, he was named to the All Big Ten first team and garnered second-team All-American. Following his college career, Hernandez played professional football. He was drafted by the Seattle Seahawks in 1983. He spent the 1983–1985 seasons with Seattle as an offensive tackle, before finishing his NFL career with the Minnesota Vikings in 1986. (Courtesy of East Detroit High Athletic Hall of Fame Committee.)

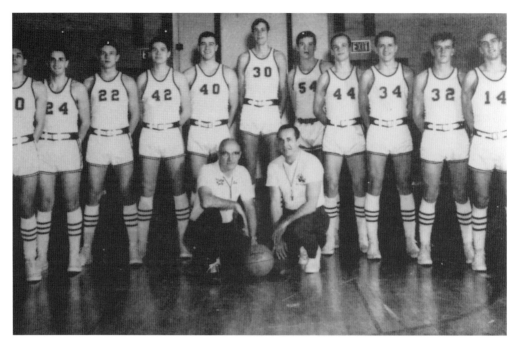

1966 Basketball Team

Fred Lee led another Shamrock basketball team to the brink of a state championship. The "Jolly Green Giants" roared through the regular season with a 16-0 record. Their closest game was a nine-point win over Roseville en route to their EML title. They were ranked number one in the state for the entire season by all press services. During the season, the team set a school scoring record in a 105-59 victory over Waterford. In the state tournament, East Detroit rolled off six more wins in the district and regional rounds, running their school-record winning streak to 22 games. Moving on to East Lansing for the semifinals, the Shams hooked up with archrival Ferndale for a classic matchup. After East Detroit stormed to a 16-point halftime lead, Ferndale kept chipping away in the second half and grabbed a 63-62 lead. The Shams' final shot spun in and out at the buzzer, giving East Detroit their only loss of the season. Ferndale went on to win the state title the next night. Most of the players and staff of the East Detroit team are pictured here, including coach Fred Lee and assistant coach Jack Roberts at center. Players in the second row (not all pictured) include Ron Binge, Bill Boyda, Tom Domlovil, Dick Erickson, Mickey Frabott, John Gordon, Doug Hess, Joe Hornung, Bill Mertz, Gorge O'Hara, Archie Price, Wally Schroeder, and Ray Taylor, manager.

Ron Binge (OPPOSITE PAGE)

Binge is proof that hard work pays off. Coming out of junior high school with an outstanding group of athletes, Binge soon came to the fore with his work ethic and determination. He earned three letters in basketball, playing both center and forward. In his senior year, he helped the "Jolly Green Giants" win league and regional championships, losing only in the state semifinals by one point. Binge led his team in points per game with 16.8, and still led the team in assists. He completed a great high school career by being named to every all-star team, including All-Country, All-Suburban, and first-team All-State. He accepted a four-year scholarship to Michigan State University, where he played for the Spartans all four years while earning his degree.

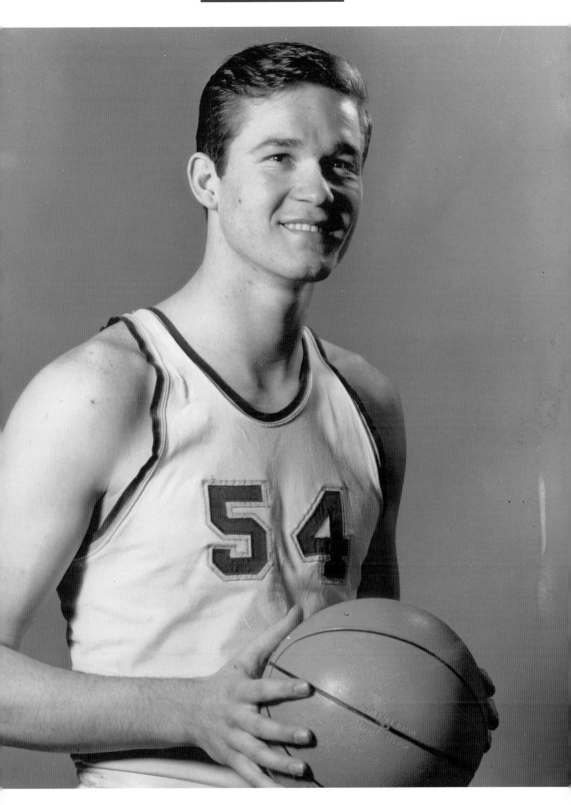

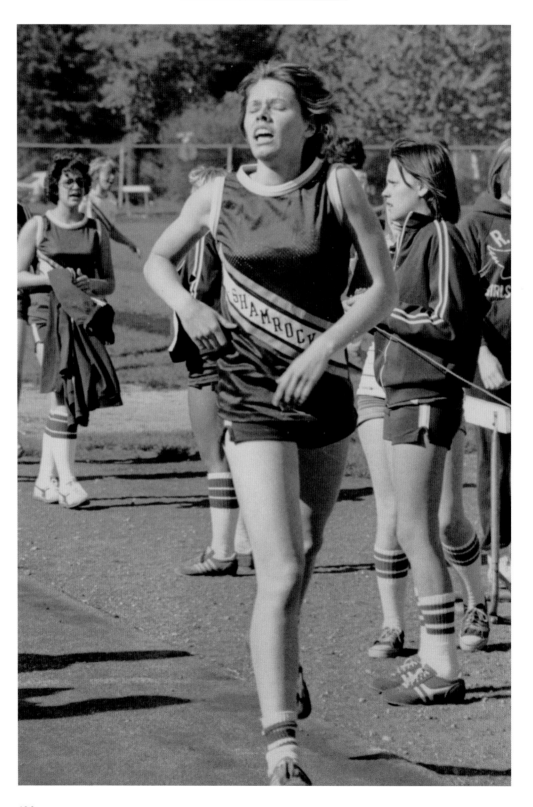

Dana Filzek

Dana Filzek was part of the 1980s golden era for female athletes at East Detroit High School. She earned eight athletic letters, including three each in basketball and softball and two in volleyball. On the softball diamond, Dana was a "sweet-swinging, slick-fielding shortstop" with a rifle arm who anchored the middle of the infield for the Shams. She was a two-time All-League selection and a first-team All-County pick in 1989. She also earned second-team All-State honors during her senior season. On the basketball court, she set school records with a 40-point game, a 602-point season, and a 78 percent free-throw rate during her senior year. Dana had six games of 30 or more points during her senior year and averaged 31.2 points a game in tournament play. She was a three-time All-EML pick, including MVP in 1988. She was also Macomb County MVP that year, as well as All-Metro, All-Suburban, and All-State. She was a member of the AAU Michigan champs in basketball in 1989 and played college softball at Central Michigan University and college basketball at the University of Michigan—Dearborn. (Courtesy of East Detroit High Athletic Hall of Fame.)

Debbie Asbury (OPPOSITE PAGE)

Debbie Asbury lettered in basketball, volleyball, and cross-country, but she's legendary in track for East Detroit High. She was varsity team captain for three years and the team's Most Valuable Player for three seasons. In her senior year, she was part of the 1978 track team that went undefeated in dual meets. Asbury herself was undefeated in the quarter-mile and half-mile events during the dual season, and also won EML and regional titles in these events. She was the first Shamrock female track athlete to qualify for the state finals, finishing third in the half-mile, which earned her All-State honors. She left East Detroit holding school records in the 220, 440, half-mile, and mile relay. She was also the MVP of the cross-country team, setting a school record in the three-mile race. After high school, Asbury received a track scholarship to Eastern Michigan, but her running career was cut short by injuries. She returned to East Detroit to coach track at Oakwood for two years. She is married to fellow East Detroiter Dave McCoy, and their children went through East Detroit schools. Her father was legendary Shamrock coach Al Asbury.

Gina Menta

Gina Menta (now Gina Milana) was another nine-letter athlete in the mid-1980s, earning three letters each in basketball, volleyball, and softball. She received All-League and All-Academic awards as a hitter in volleyball and collected many honors on the softball diamond as she led the Shams to two league titles and a district championship. She earned the MVP title of the regional league in her senior season and was named to the All-State team as well. In basketball, she set many school records, including 1,239 points, 917 rebounds, and 200 blocked shots. She led the basketball team to two EML titles and two district crowns. Her awards include being named All-County three times, named to the *Detroit Free Press*, *Detroit News*, and AP All-State first teams in her senior season, and being named to the United Press Michigan Dream Team. Following high school, Menta played two years of basketball and softball at the University of Detroit and played semi-pro softball as well. She continues to stay active in recreational sports as she raises her family. (Courtesy of East Detroit High Athletic Hall of Fame.)

Jenny Wilson

Jenny Wilson (now Jenny Goodpaster) was a standout athlete at East Detroit and is today an excellent athlete and coach. While at East Detroit, she earned seven letters, two each in basketball and volleyball and three in track, where she left her mark in the Shamrock record books. Jenny (left) was captain and MVP of the 1984 team as well as All-Conference, All-County, and All-Regional, and was a state qualifier in the 800, 1600, and 3200 meters in both her junior and senior seasons. An athletic scholarship took her to Hillsdale College, where she earned 12 letters from 1984 to 1988 and became an academic All-American as well as a track All-American while setting district and college records in the 1500 meters. She was Michigan Runner of the Year in 1999 and qualified for the 1996 and 2000 Olympic Trials in the 5,000 meters. She was named Regional Coach of the Year at Holland's Hamilton High School in 1994 before moving to Hillsdale College, where her team finished eighth in the nation in her first season. (Courtesy of East Detroit High Athletic Hall of Fame.)

Roxanne Szczesniak

Roxanne Szczesniak was one of the first outstanding female athletes at East Detroit High. Although she earned two letters in basketball, she excelled in softball. As a high school sophomore in 1978, she led her team to district and regional championships and was named All-State, having batted .368. As a junior, she led the way to a district championship and was named All-League. In her senior year, she pitched three no-hitters, one perfect game, and had a .350 batting average, all of which earned her All-League, All-County, and All-State honors. At Wayne State, she continued as an outstanding athlete and was named regional All-American twice and All-American in her senior year. Her team won their conference three of her four college years and twice received an NCAA regional bid. Her earned run average in conference competition was 0.00 for the last two years she pitched for Wayne. (Courtesy of East Detroit High Athletic Hall of Fame.)

Tom O'Hara

The O'Hara family has been the predominant athletic family in East Detroit High School sports. It started with Tom O'Hara (center), who played with Ron Kramer in football and basketball. In 1952, the basketball team compiled a 12-3 record, winning the regional and losing to Highland Park in the quarterfinals. In 1953, the Shamrocks captured the EML and regional titles in basketball. By the time he graduated in 1954, Tom had three letters in football and four in basketball. He is pictured with coach Al Asbury and sophomore halfback Bill Rogers as they plan strategy for the homecoming game. Tom was followed by his brother, George O'Hara, who played from 1964 to 1967, excelling in basketball, baseball, and football. As a guard, he led his team in assists and scored a career total of 664 points. He was named All-Suburban and second-team All-State. He was named All-League, second-team All-County, and All-State honorable mention. After graduation, he played basketball one year at Eastern Michigan University and continued playing baseball with the American Legion, participating in the 1967 All-Star game at Tiger Stadium, leading the league with a .382 batting average.

Steve Sandles

Sandles occupies a special place in EDHS track history as the only Shamrock to win two individual state titles in one season. He earned five letters while at East Detroit. As a running back and safety, Sandles earned two football letters while also serving as captain of the team in his senior season. However, track is where he shined. The 1989 team can make a case as the best ever Shamrock track-and-field team, as they were 8-0 in dual meets and won the league and state regional team meets. They placed seventh in the Class A state finals, with 10 members qualifying for the finals. Sandles was the leader of the group, winning two state titles—in the 200 and 400 meters. His time of 47.22 seconds in the 400 was the fourth fastest in state history at the time and still stands as the seventh fastest time in history. Steve also was All-County in the 200 and 400 meters and set a league record in the 200 with a time of 21.67 seconds. Sandles broke four Shamrock track records with times of 10.60 seconds in the 100 meters, 21.50 in the 200 meters, 47.22 in the 400 meters, and 1:56.4 in the 800 meters. Following high school, Sandles also claimed the 400-meter title at the Midwest Meet of Champions in Indianapolis and was a member of the winning one-mile relay team at the same meet. (Courtesy of East Detroit High Athletic Hall of Fame.)

INDEX